Otto

Wagner

Gustav

Klimt

Otto

Wagner

Gustav

Klimt

HDi
HARPER
DESIGN
international

An Imprint of HarperCollinsPublishers

Publisher: **Paco Asensio**

Editorial Coordination and Text: **Llorenç Bonet** (text on pages 14-34: **Sol Kliczkowski**)

Translation: **William Bain**

Art Director: **Mireia Casanovas Soley**

Graphic Design & Layout: **Emma Termes Parera**

Copyediting: **Dan Truman & Gyda Arber**

Photographs of Klimt: © **ARTOTHEK**

Photographs of Wagner: © **János Kálmar**
Glassergasse 6, A-1090 Vienna, Austria
info@janoskalmar.at
Drawings in the specified pages were taken from the following institutions:
© Historisches Museum der Stadt Wien, in pages: 16,18, 19, 43, 51, 53
© Austrian National Library, Bildarchiv, in page: 6, 32 .

First published in 2003 by:
Harper Design International,
an imprint of HarperCollins*Publishers*
10 East 53rd Street
New York, NY 10022

Distributed throughout the world by:
HarperCollins International
10 East 53rd Street
New York, NY 10022
Tel: (212) 207-7000
Fax: (212) 207-7654

HarperCollins books may be purchased for educational, business, or sales promotional use. For information, please write:
Special Markets Department HarperCollins Publishers Inc. 10 East 53rd Street New York, NY 10022

Library of Congress Control Number: 2003109564

ISBN: 0-06-056422-9
DL: B-32-874-03
Editorial project

LOFT Publications
Via Laietana, 32 4º Of. 92
08003 Barcelona. Spain
Tel.: +34 932 688 088
Fax: +34 932 687 073
e-mail: loft@loftpublications.com
www.loftpublications.com

Printed by:
Anman Gràfiques del Vallès, Spain

First Printing, 2003

 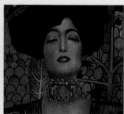

Contents

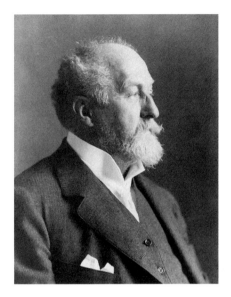
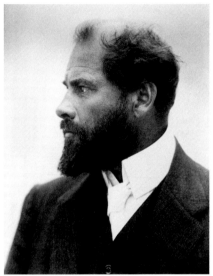

OTTO WAGNER AND GUSTAV KLIMT
VIENNA: END OF EMPIRE

At the 19th century's end, the world found itself in a deep crisis that many historians consider to be the germ of the First World War. Society was fragmented into groups and an individual's status was no longer solely determined by social position. Religion and the very idea of God, colonialism, morality and decorum, the arts, economics, and science—all of the truths once held to be unalterable began to be questioned not only by philosophers and artists but by all strata of society. The fallacy of positivism began to be harshly criticized with the realization that industrialization and science can bring enslavement of a society's workforce in addition to cyclical economic crises that can destabilize an entire country. Not only was a whole political-economic system changing, the very conception of the world and humankind was altering with it.

Vienna had enjoyed an economic resurgence starting around the mid-19th century; with its one million inhabitants, it was one of the most important capitals in Europe. Faced with the changing world, two individuals emerged to bring modernity to Vienna.

Convinced that art—especially architecture—acts positively in people's daily lives, Otto Wagner set out to make his work contribute to social harmony, through its functionalism and beauty. His position, unquestionably positivist, contrasts with that of Gustav Klimt, who questioned the fundamental truths of 19th century society and make its crises evident. The main subject of Klimt's work, self-sufficient female figures, came as a direct attack on a Europe where women were not even allowed to vote. In spite their opposing views—Apollonian/ Dionysian in Nietzche's terms—both these artists initiated modernity in Vienna. They were the masters of the next generation of artists: Klimt launched the careers of painters Oskar Kokoschka(1886-1980) and Egon Schiele(1890-1918) at a 1908 exhibition, and the architects Joseph Hoffman(1870-1956) and Joseph Maria Olbrich(1867-1908) were, like countless others of their generation, taught by Wagner.

Wagner and Klimt worked in this period of maximum splendor in Vienna in a strange time that made possible the maintenance of an anachronistic empire that was incapable of adapting itself to modern Europe. In this extensive period, which began in the last decade of the 19th century and brusquely ended with the "Great War," the modernity to which we are still indebted was launched.

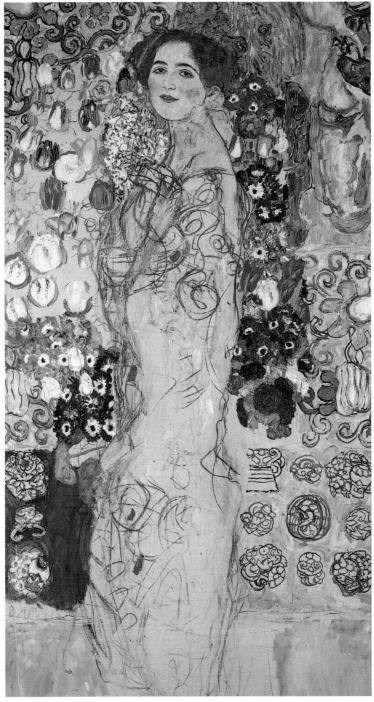

Portrait of a Lady
1917-1918. Oil on canvas (70.8 x 35.4 inches)

OTTO WAGNER

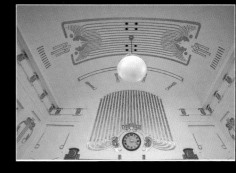

OTTO WAGNER 1841-1918

Through the close of the 19th century, Vienna oscillated between being the capital of the absolutist and nearly feudal Austro-Hungarian Empire and being one of the most modern cities in Europe. Viennese civil society met the challenge of applying technical, scientific, and aesthetic innovations that transformed Europe over the course of the 1800s, in spite of the empire's political thought.

Otto Wagner was a fundamental figure of this era. Until the age of fifty, he worked as a renowned neoclassical architect who followed the teachings of his master, Gottfried Semper (1803-1879), along with the inevitable influences of Prussian architect Karl Friedrich Schinkel(1781-1841). Beginning in the 1890s, Wagner moved progressively toward a modernization of the building arts, culminating in 1894 when he was accepted as a member of the Academy of Fine Arts of Vienna, where he would also teach. His alliance with governmental institutions—including the Academy, the 1894-1897 commission for the city's metropolitan railway, among others—did not stop Wagner from influencing architects who were critical of these institutions. Josef Maria Olbrich(1867-1908) and Josef Hoffmann(1870-1956), instigators of the Vienna Secession, an artistic rebellion formed to create a new artistic style, worked in Wagner's private architectural studio in the 1890s. When they moved on to other things, they remained on good terms and even collaborated on projects. Wagner may not have been one of the instigators of the Secession, but he certainly collaborated widely with the group with covers and articles for their journal *Ver Sacrum* and actively participated in group meetings.

Wagner's studio is considered by many historians to be the first modern architecture studio, preceding that of Peter Behrens(1868-1940), a judgment shared by Gropius, Mies van der Rohe, and Le Corbusier. The studio's influence was unmatched in prestige and popularity throughout all social strata, from the most conservative to the most liberal.

Apart from his classes at the Academy, Wagner gave an anti-academic course in architecture at the School of Architecture on the Schillerplatz, and his book *Modern Architecture*(1895) served as a reference point throughout Europe for years. The generation of Adolf Loos(1870-1933) was also influenced by this master: Loos admired the functionalism and the rationality of

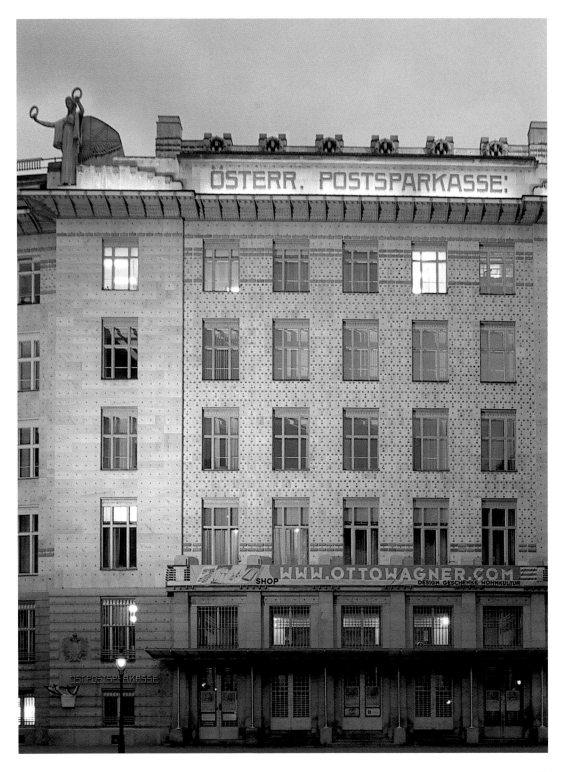

11

his work, but advanced toward the more modern school by attacking neoclassical ornamentation that Wagner had embraced. In spite of their differences, both men are considered initial members of the Vienna school. Loos learned from Wagner—as Wagner had from Schinkel—the importance of perspective and the ordering of the façade within its setting. When he wrote his famous article against ornamentation (*Ornament and Crime*, 1908), Loos was certainly primarily thinking of the architecture of Wagner and his followers.

Wagner learned from Schinkel's neoclassicism and romanticism and from the Central European baroque tradition. But he was able to modernize this legacy with new needs and techniques, such as ironwork. He did not react against the Central European tradition, rather, he modernized their forms and the spaces themselves by adapting them to new uses. This balance between tradition and modernity is a constant in all of his work, and perhaps his greatest achievement. This same dichotomy between the traditional empire and industrialization was the hallmark of the time.

As a teacher, Wagner combined solid historical and technical foundations with practicality. Politically he favored state support of art: he gave special importance to artists whose work facilitated the evolution of their country, an idea shared by the other members of the Vienna Secession.

Wagner's works as an urbanist were based on an ordered growth of the metropolis with a ring system (*Project for the Extension of Vienna*, 1910), following the plan of the old Vienna wall and the Ringstrasse, although it was a copy of schemes from the 1850s.

Otto Wagner initiated the Viennese school of architecture. He was one of the first European architects to introduce new building materials. At the same time, he desired a functional and pragmatic architecture without losing sight of taste and decor. Without his work for the government and the most critical sectors of Viennese society, the Austrian capital would be very different, not only because of its buildings but because of the cultural inspiration Wagner gave the city.

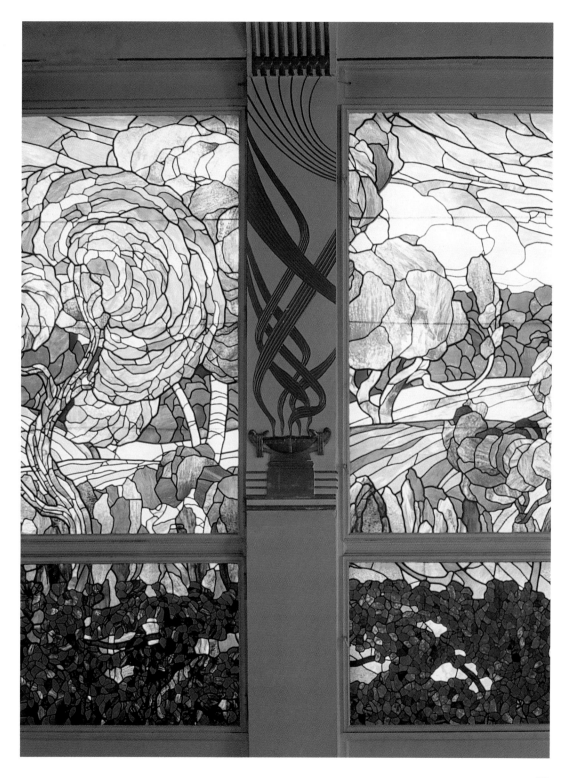

LÄNDERBANK

1883-1884

Hohenstaufengasse 3, Vienna

This work marks the beginning of a new phase of Otto Wagner's architecture. What the architect inherited from classicism may be glimpsed here, yet modern techniques and new materials are introduced. The building methods stand out for their functionalism, elegance, and spatial organization. The architect thus uses the praxis contained in one of his sentences: "It cannot be beautiful if it is not practical" (*The Architecture Of Our Time*). From the outside, the building's façade is clearly traditional and does not reflect the interior structure. Set on an irregularly shaped site, the bank has been set by the architect on a circular plan. The vestibule thus becomes the main axis of the whole mass. *Abstract Austria*, sculpted by Johannes Benk(1844-1914), echoes this circular arrangement via its placement at the junction with the main room. The lobby also suggests a Tuscan design, with a play of columns alternating round pilasters with square ones, and incorporates a lantern roof of iron and glass, utilizing one of the technological advances of the 19th century.

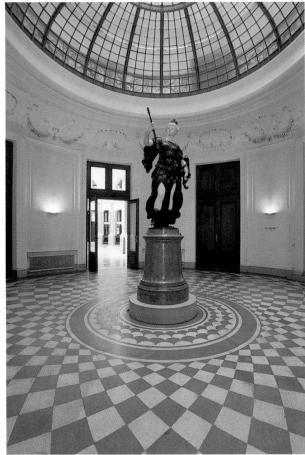

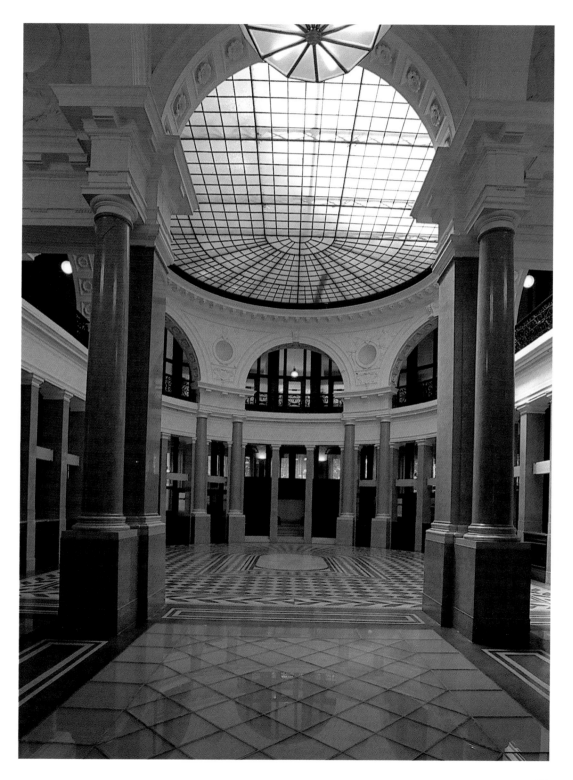

WAGNER'S VILLAS

1886-1888/1912-1913

The first of the Wagner Villas is a house in the classical tradition. Otto Wagner built it as a summer residence after his second marriage. One salient feature is its great symmetry; another is the innovative use of iron in the railings of the staircase. The house is designed on a square plan with a transversal axis with two galleries. The entrance has a long portico with four columns. Essentially made of stone, the galleries include windows of stained glass.

The second villa exhibits a great creative capacity: freedom in the rooms, geometrical decoration, and asymmetry in the entrance and the gallery. Wagner went beyond the established architecture (influenced largely by Loos and Hoffmann) with his use of blue and white majolica tiles. He gives special importance to the entrance and strongly states his own presence with a plastic work in the small window decorated by Kolo Moser(1868-1918), an artist and a founding member of the Secession.

In comparing the two villas, one can clearly see the architect's development, including a renunciation of classical style in the second piece, the last and most modern of his works.

Hüttelbergstrasse 26/Hüttelbergstrasse 28, Vienna

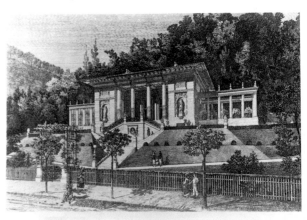

Villa des Herrn W. in Hütteldorf bei Wien.

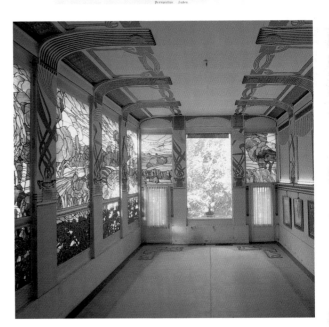

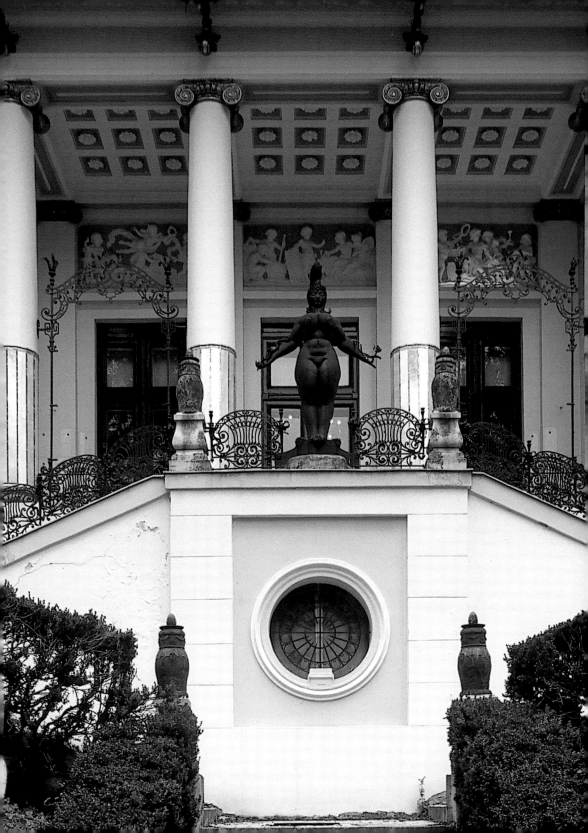

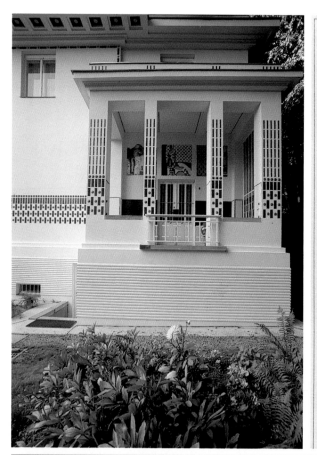

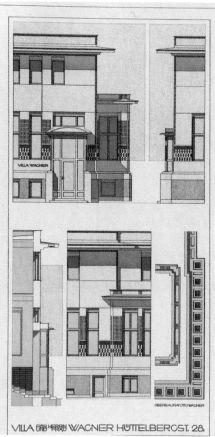

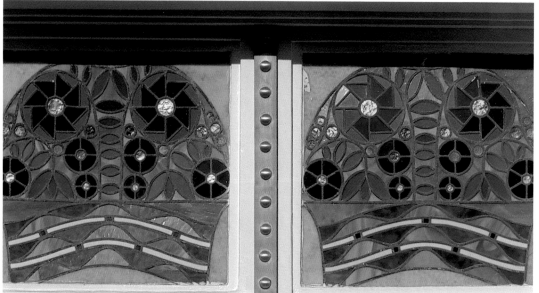

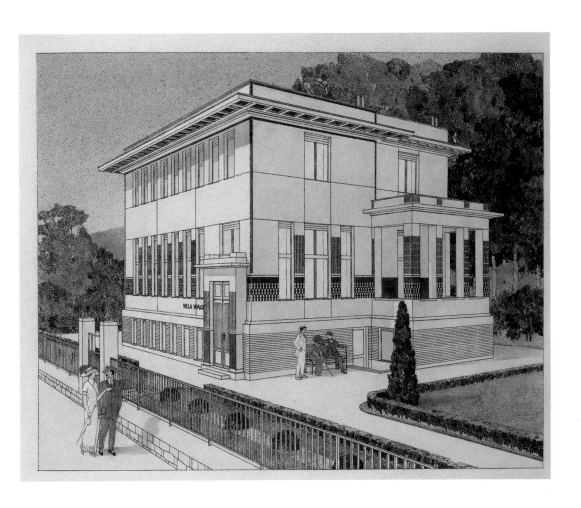

Basement

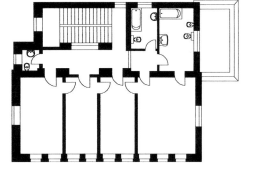

First floor

MAJOLICA HOUSE

1898-1899

Linke Wienzeile 40, Vienna

With this residence, Wagner opened himself to the revolutionary spirit of the age at a crowning moment of his career: along with another house on the same street (Linke Wienzeile Building 38), he provoked the disapproval of the Künstlerhaus conservatives. The façade of the Majolica House is distinct from that of the adjacent house (also by Wagner) because of the building's pink floral whirls printed on majolica tiles—hence the house's name—and the lions framing the windows. The floors of the two buildings are not in alignment but are joined by a series of balconies that are set back from the front. It is by these means that the Majolica House presents its façade flanked by two "columns" of balconies. Inside, the staircase, which houses an elegant elevator decorated in the secessionist style, governs the vertical axis, interrupted by the short passageways of each mezzanine floor. For the whole length of the stairway, the curved lines and the design of the elevator housing and of the staircase handrail express the creativity of the young secessionist movement.

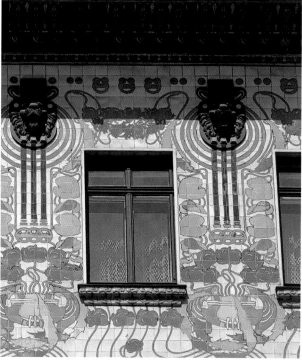

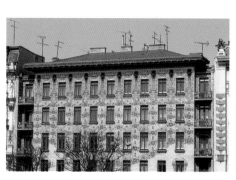

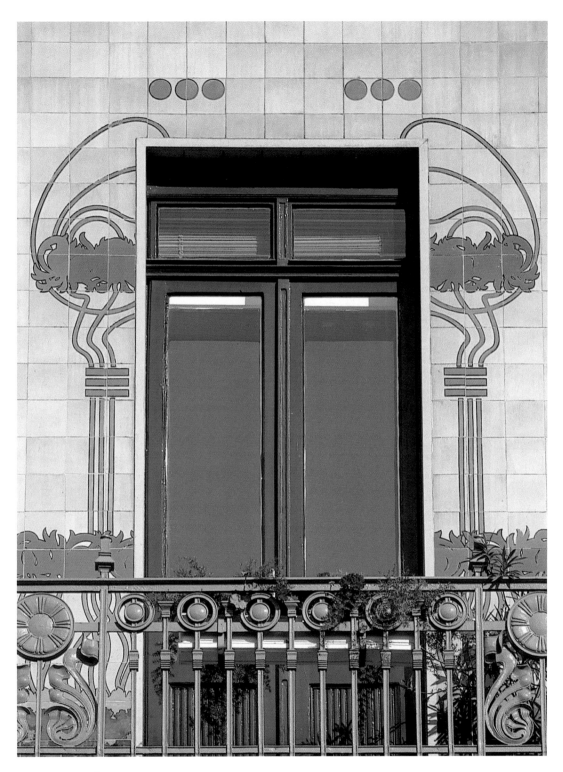

LINKE WIENZEILE 38

1898-1899

Beside the Majolica House, Otto Wagner raised this house on the Linke Wienzeile (originally called Magdalenenstraße). The two buildings are very striking because of their ornamental façades, and this one is decorated in gilded stucco. The facings were designed by Kolo Moser, whose rich decorations featuring cascades, leaf motifs, and medallions bearing women's faces cover the façade and contrast with the floral motifs on the neighboring block. The commercial space behind the display windows on the ground floor lightens the weight of the structure. The first floor is joined to the second via staffs that project upward. Wagner paid special attention to the design of the "rounded corner," which has three windows per floor. Crowning this are two bronze sculptures by Othmar Schimkowitz(1864-1947). As in the Majolica House, great care was taken in the internal details—staircase, elevator, handrail—to mark the social status of the people who would live here.

Linke Wienzeile 38, Vienna

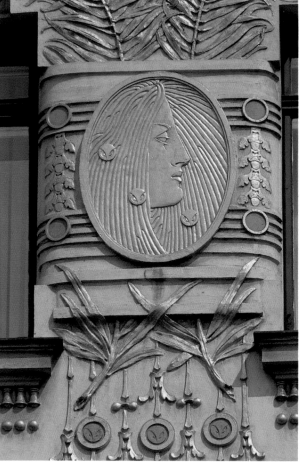

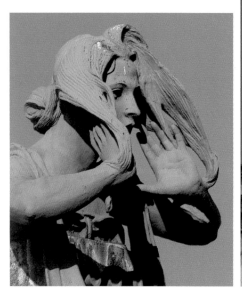

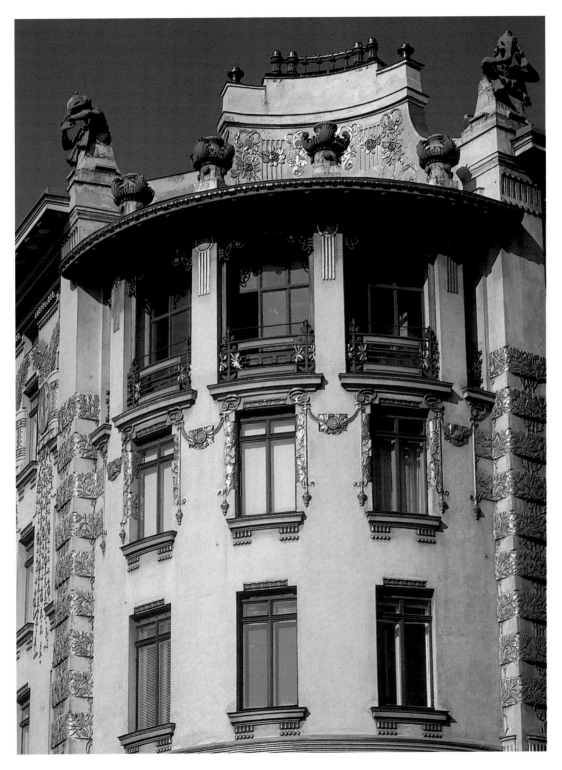

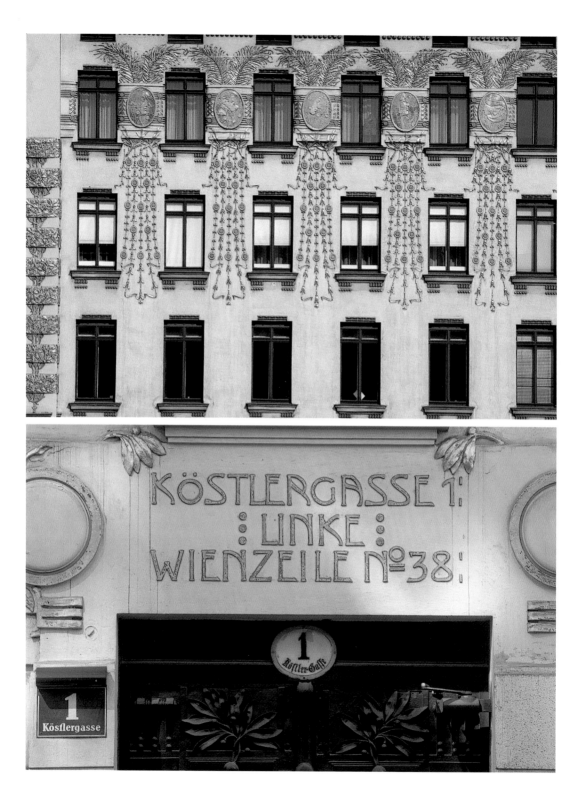

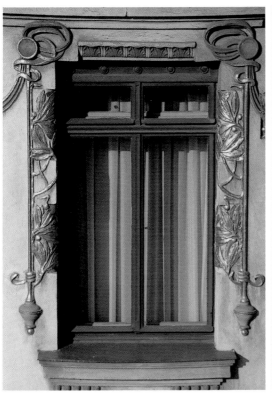

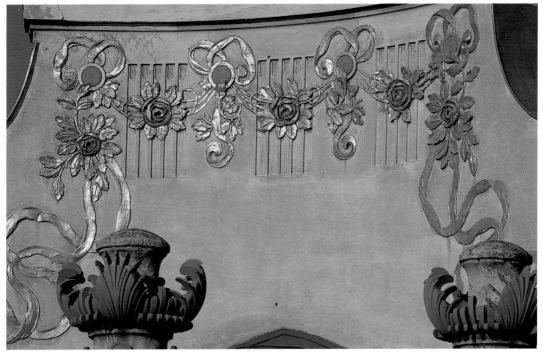

Vienna Metro Stations

1894-1901

The Stadtbahn (Metropolitan Railway) was Wagner's first commission after he was named official adviser for the construction of the Vienna Town Hall in 1894. The stations would be gradually inserted into the urban landscape, adapted to the buildings around them. This is especially clear if we look at the different stations over the course of the line's growth, like Gersthof or Rossauer Lände. The different stations are links that mark Vienna's city landscape and transport their design in the direction of the U-bahn/S-bahn system. Their design varies according to whether the rails are elevated or subterranean, but throughout the system what predominates is the use of iron painted in green and an enormous wealth of technical ingenuity, confirming its connection to Art Nouveau. However, classical inspiration can hardly be said to disappear either: it is transformed and adapted to the use-oriented ideal and the clarity of modern times.

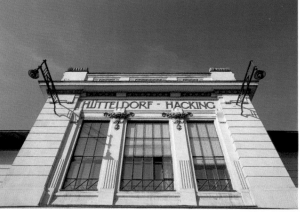

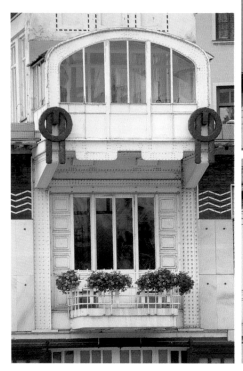

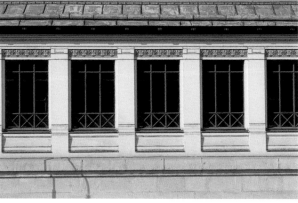

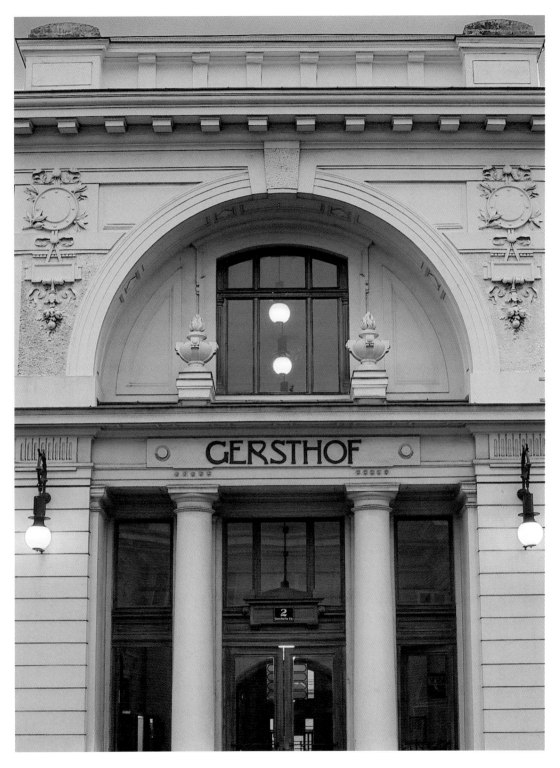

VIENNA METRO: KARLSPLATZ STATION

1898

Wagner built the Karlsplatz station using two pavilions with the idea that its grandeur would match that of the two Habsburg residences, the city home in Hofburg, and the summer one in Schönbrunn. Unlike the other stations, these employ a self-supporting panel structure on iron faced in white marble. The interior panels are not marble, but plaster. The initial project included a dome to crown the station, but after final approval was given for the square—one of the most important in Vienna—its construction was rejected and the station entrances received more functional treatment as symbols of modernity. The whole was decorated according to secessionist design concepts, which also contributed to its innovation. On this project, the architect combined the liveliness of the colors with the abundance of Art Nouveau motifs: colors alternated with gilt decorations and the white and green of the framework.

Karlsplatz, Vienna

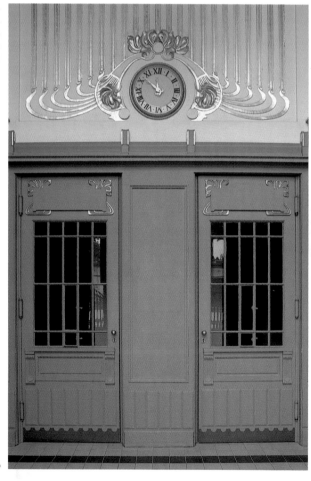

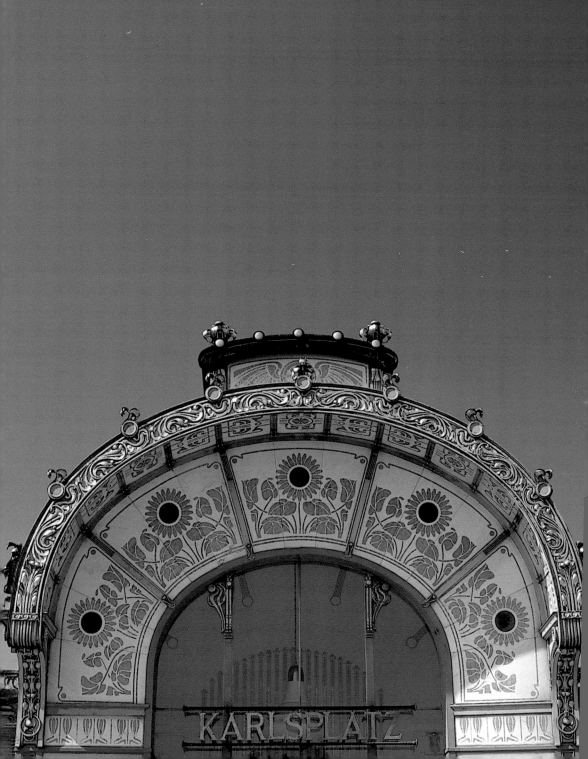
KARLSPLATZ

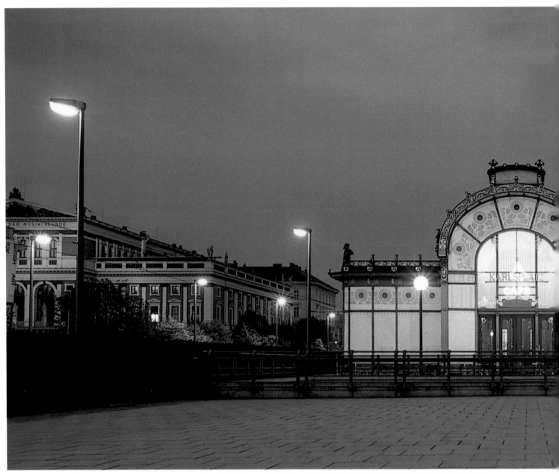

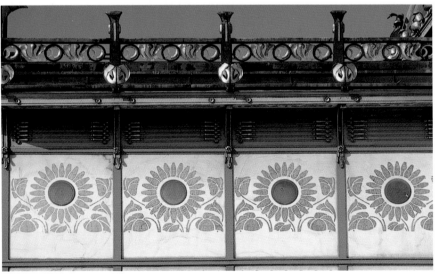

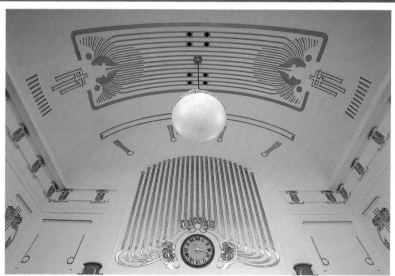

STEINHOF CHURCH

1902-1907

Baumgartner Höhe 1, Vienna

Otto Wagner won the competition for the development of the extensive project which forms part of the psychiatric complex at Steinhof. With this building the architect was proposing the creation of a church for contemporary humanity. Situated at the highest point on the landscape, it dominates the complex. The influences on this piece are highly varied in type: the framing is neoclassical, the spatial organization evokes the Renaissance, while the overall suggestion is baroque. The work displays a wonderful play of forms, light, and fields. The dome is faced in copper panels and suggests Balkan architecture. Representing the secessionist movement, Kolo Moser's stained glass windows stand out, as do Remigius Jeiling's and Rudolf Jettmar's altar mosaics, Richard Luksch's statues, and the angels by Othmar Schimkowitz. Outside the building, the stone foundation contrasts with the marble panels. Inside, the dome is closed by a vault comprised of a fine gilt netting with small white square panels. By taking the ceiling down 56 feet, the acoustics and heating problems were solved.

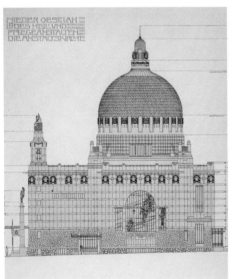

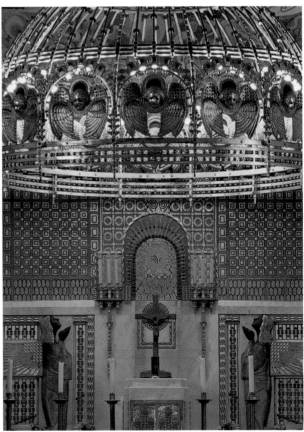

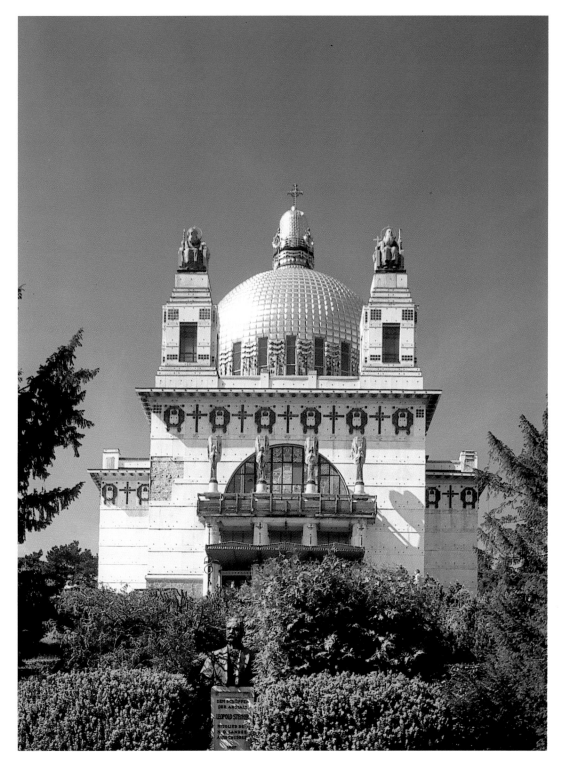

Postsparkasse of Austria

1903-1912

Departing from his previous work, Vienna's Post Office Savings Bank represents the architecture of the new century. The aim of this building was clear: the architect wanted to present a container appropriate to what it was to contain: money. The placement, which stands out monumentally at one end of the square, does much to showcase the column flanked by two attached figures, the work of Schimkowitz, that reign like two protective goddesses on high. The whole work is faced in granite and marble panels studded with aluminum rivets. These latter elements are concentrated in greatest density on the central façade, as if to emphasize its presence. Aluminum was also used for the radiators, the entrance marquee, the pilasters of the main bay, and the statues. Once again, Wagner's personal language speaks in repeating spaces and ironwork decoration. At a time when the Secession was breaking up, Wagner was able to transcend Art Nouveau and the baroque trend.

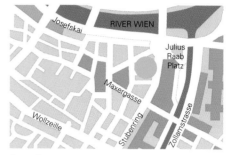

Georg-Coch-Platz 2, Vienna

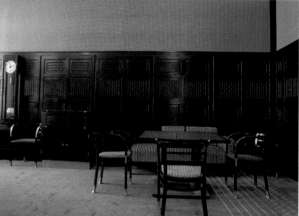

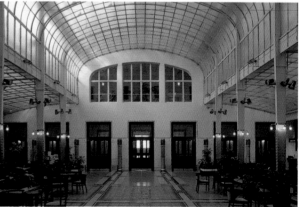

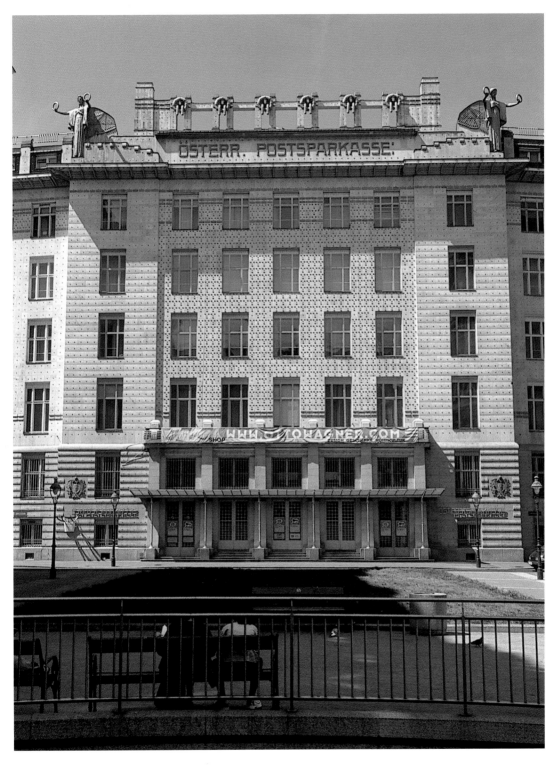

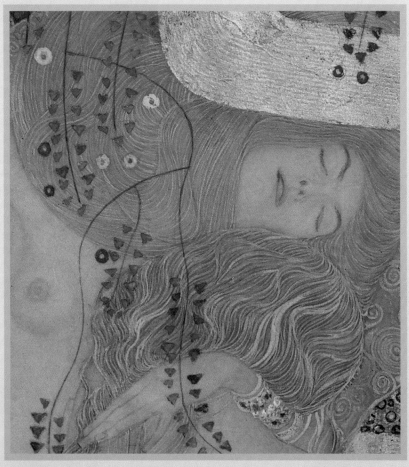

Water Serpents I
1904-1907. Mixed media on parchment (19.69 x 7.87 inches)

GOLDEN COLORS

The surface of architecture
and the background of painting

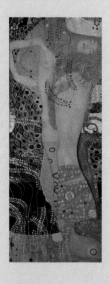

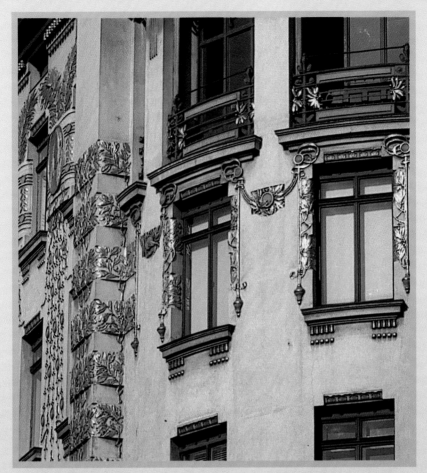

Houses on the Linke Wienzeile

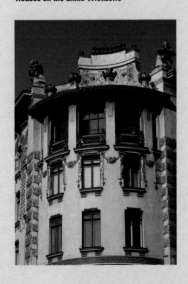

Gold represents wealth, but in Vienna it also evokes the Byzantine Empire with its icons, jewels, and architectural decoration. But Byzantium considered as the mythical antecedent of the Austro-Hungarian Empire represents both the nostalgic and the exotic. Klimt's gold backgrounds contrast with unrealistic Renaissance perspectives, and the ornamentation of Wagner's buildings progressively began to show off less classical elements. Tradition and exoticism, luxury and unreality: vectors in the direction of modernity.

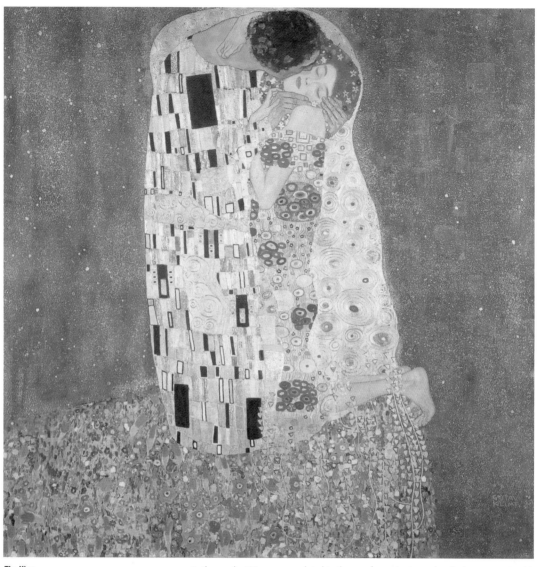

The Kiss
1907-1908. Oil on canvas (70.87 x 70.87 inches)

In the works Wagner completed in the 1880s, small elements painted in gold had already appeared: this technique highlighted capitals or moldings. Klimt, trained in the same aesthetic as Wagner when it came to recovering from antiquity, also used gilt in his first pieces to bring out details like a crown of laurel or the halo of a saint in works. Both men used gold with a greater profusion than was traditional at the end of the 1890s.

In the *Beethoven Frieze* (1902), Klimt for the first time gave free rein to a personal style with the color gold playing a starring role. What in previous pieces such as *Hygieia* was only a decorative

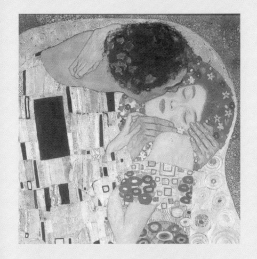

The woman's face is the center of attention of the whole painting, and both the man's head and his hands (as well as the veil surrounding them) are directed toward the expressionless face of the young woman. Her pallid visage stands out because of the color amid the gold. Moreover, it is the most realistic element in the picture, along with the other visible body parts. If the face shows a total lack of activity, the female hands—the left holding that of the man, the right tensed and poised—denote great expression, as if to make up for the expressionless face. Her feet also contrast with the face: they are in tension because of her posture, and they are also outside the veil and the green lower strip, which may represent a field.

The bodies of the woman and the man merge in a mass of gold and other colors. But while these abstract forms hide their anatomies, they reveal the difference between the male and the female figures. How? By the predominance in the man's figure of black and white rectilinear forms and, in the woman's figure, the circular forms in bright colors. Fusion between the sexes proves impossible: in spite of their unity, they remain separated.

The transformation of the clothing into abstract surfaces that merge with the human form is a technique that permitted the painter freedom to recreate himself in his decorative aesthetic, and not always gratuitously, since the representation could be symbolic, as is the case here.

At that time, making a building exude warmth required the use of human figures in sculpture or reliefs. This is the premise followed by Wagner in the design of no small number of his edifices, as is indeed the case with that located at number 38 of Linke Wienzeile Street (1898-1899). At this time Wagner was working with fellow secessionist and sculptor Kolo Moser. Gold was the dominant color in the Olbrich pavilion, a construction raised only a year later and which breathes the spirit of the group not only through its forms but also precisely because of the predominance of this color.

The adjacent building (known as the Majolica House) was built by Wagner at the same time. While the two are in many ways similar, Wagner here opted to work only with colored ceramics and to omit any human figures, from which it may be deduced that the decoration with forms and figures held no purpose beyond that of novelty and a striking motif.

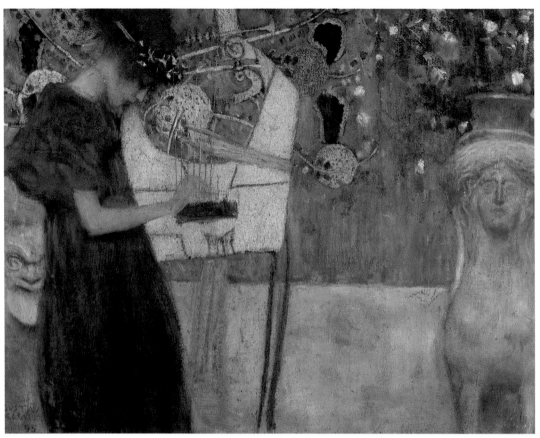

Music I
1895. Oil on canvas (14.57 x 17.52 inches)

motif became a veritable invasion: the armor, the hair, the embracing couple; the mural shows a predominance of gold and the smooth preparation of the painting surface is colorless. The figures in the frieze are two-dimensional and there is practically no context to frame the *dramatis personae* or the action.

The *Beethoven Frieze* is a step toward the pictorial revolution of the "gold period": figures framed in golden surface frames, without attributes, without any notion of space or time. With this resource, the painter defied the preemi-nence of the Renaissance perspective, along with the need to create a well-defined historical context, one of the sacred rules of the academy. But both were omitted by Klimt.

Klimt's gold period is born of his interest in medieval Byzantine icons, objects where the realism and the perfection of the human body—of a saint, of Christ—contrast in an abstract setting totally covered with gold leaf. These paintings impressed Klimt, who came to use gold leaf in an attempt to return to this earlier aesthetic. Byzantine icons were not rare

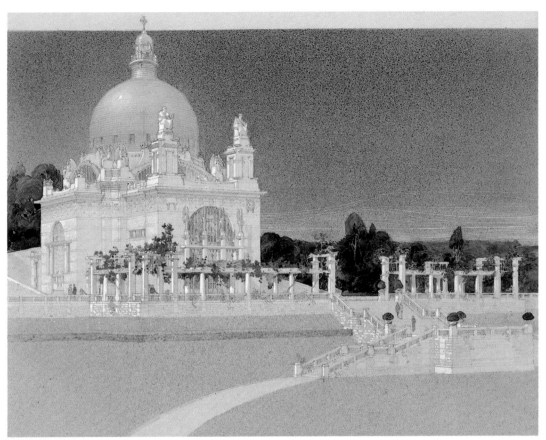

Steinhof Church, ink and watercolor

in Vienna, which was close in both geographical and historical terms, since Austria considered itself the legitimate successor of the Byzantine Empire. Byzantine objects were looked at with a mixture of reverence and decadence: a common tradition yet an exotic one, its origins in the Ottoman Empire. This juxtaposition was highly attractive to the painter who scandalously not only bestowed an aura of sacredness and exoticism on his own pieces but also destroyed all traces of classical perspective.

The exotic mindset also constituted a source of inspiration for Wagner, but in a highly different way. The Steinhof Church, for example, with its "golden" dome, alludes directly to the Russian Orthodox churches and, via its form, to the Ottoman mosques like Saint Sophia in Istanbul (the former Constantinople). In spite of this link to the past, Wagner set out to raise a very modern structure, with large stained glass windows, a dome with planned acoustics, and advanced thermodynamics.

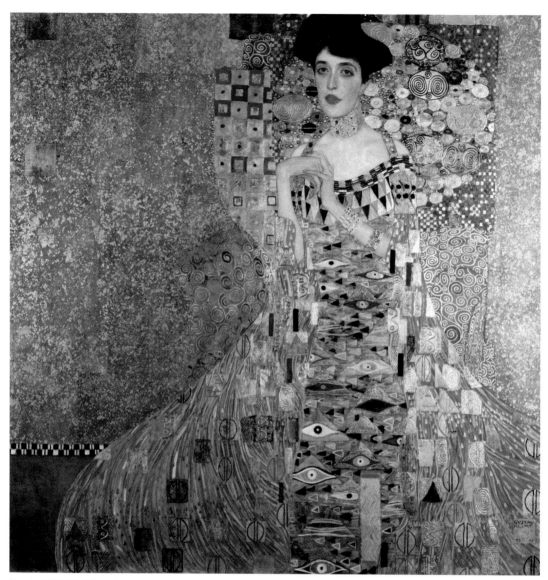

Portrait of Adele Bloch-Bauer I
1907. Oil on canvas (54.33 x 54.33 inches)

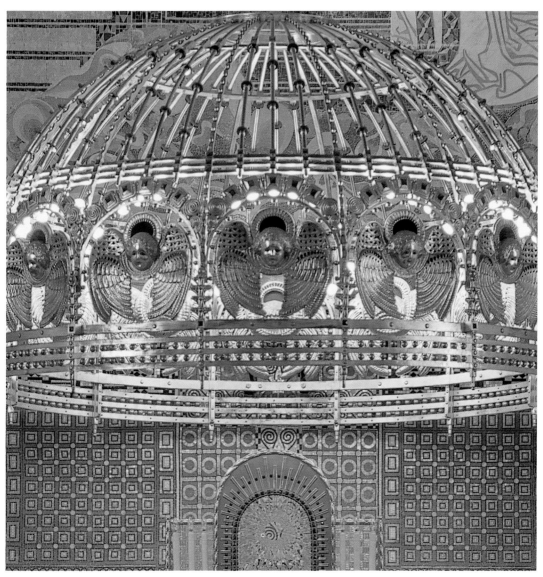

Interior of the Steinhof Church

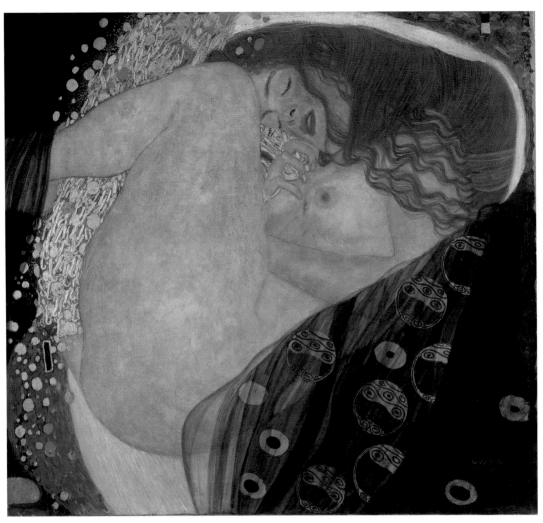

Danae
1907-1908. Oil on canvas (30.31 x 32.68 inches)

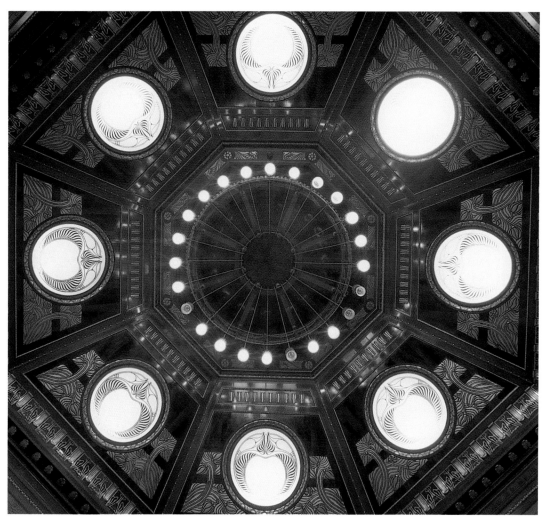

Artisanal roof of the Hofpavillon

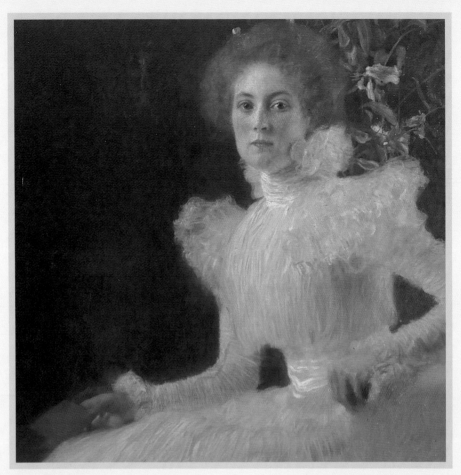

Portrait of Sonja Knips
1898. Oil on canvas (57 x 57 inches)

BOURGEOIS LIFE

The flowering of fin-de-siècle Viennese art

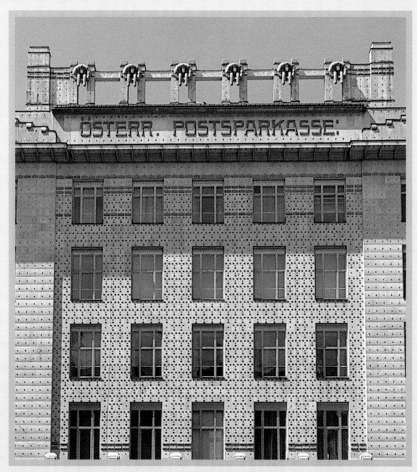

Postparkasse

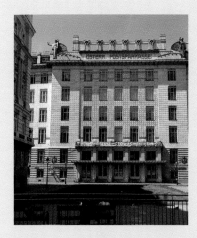

As the son of a notary public, Otto Wagner received the education of an aristocrat: he studied at the best schools in Vienna and later in Berlin. Klimt came from a family of artisans of Bohemian origin and never entirely lost his provincial accent. But in spite of their social and age differences (Wagner was 21 years older than Klimt), they were both part of the group of liberal professionals that made Vienna one of the most dynamic cities of Europe.

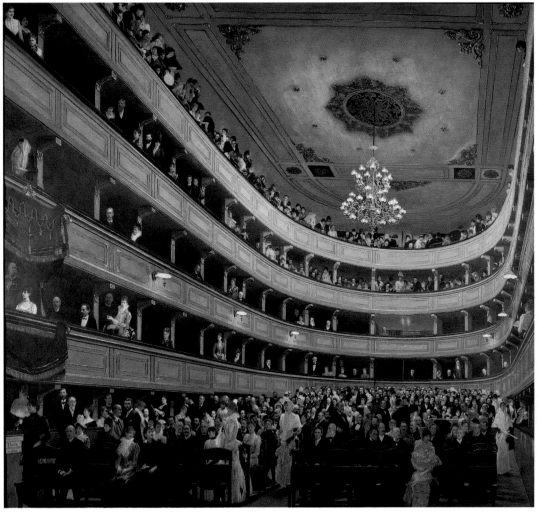

Auditorium of the Old Burgtheater
1888. Gouache on paper (32.28 x 36.22 inches)

Via the work of Wagner and of Klimt one can observe how the Viennese society of their time was formed: the painter's many female portraits provide us with an idea of the tastes and interests of his clients just as the public and private buildings of the architect exhibit some of the needs of the large city and its transformations. Otto Wagner and Gustav Klimt marked the intellectual life of fin-de-siècle Vienna, and their works contributed to the artistic movements taking place there, each in his own way. Wagner represents the modernization of architecture based on simplifying the baroque and neo-classical legacies and the assimilation of the new building materials; Klimt is the source of a break with the past and the opening of Vienna to the movements, such as Orientalism, that were triumphing in Paris or London. Wagner's age and interests link him with the past, with the splendid Central European baroque and with the neo-classicism of Karl Friedrich Schinkel (in Berlin, Wagner studied with one of Schinkel's disciples). Moreover, he worked from the institutions created by the *ancien régime*, like the Academy of Fine

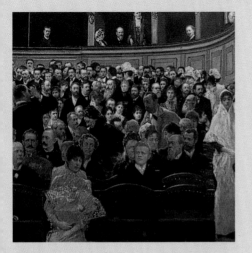

Almost all of the figures portrayed in the Auditorium of the Old Burgtheater are spectators from the Viennese wealthy classes. The news that Klimt was painting a choral portrait was spread among interested parties, who then went to the painter's studio to learn first-hand what was happening. As it was impossible to take notes from life, Klimt portrayed these people based on individual or family photographs. But the light sources in the photographs were different and this was very difficult to adjust for in the painting. The mural's lighting is thus somewhat forced: for example, a figure with light falling on it from the right while the one beside it is illuminated from the left.

Some personages appear with opera glasses, or covering their faces, or gazing toward other parts of the scene as a way of establishing relationships among the different parts of the picture (from the orchestra to the boxes, and vice-versa). There are also figures portrayed looking out at the viewer of the painting, which confers greater depth to the work. One more detail in this carefully executed piece is that all of the people portrayed were looking to see who else the painter had included.

The figures in the boxes are also included. Here, it was easier to individualize people because the black background brings out the figures. However, the foreshortening of the boxes make the portraits look somewhat forced. In spite of the problem of the different lights in the orchestra, Klimt was much praised for this work and won a prize for it in Paris. The quality of the portraits and the novelty of the subject brought fame to the picture and its author, who was beginning to stand out among other artists in the city. Selecting as a subject the spectators themselves and not a historical event made the bourgeoisie the protagonist of the painting, a discipline traditionally reserved for great patriotic or moral themes.

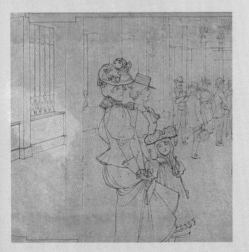

Wagner's drawings show his talent and capacity as a draftsman and his interest in capturing on paper the reality of the moment. This sketch is a fragment of the project for the Karlplatz station, and in the foreground is a female figure dressed in the latest style and placed on the station platform. A comparison of this drawing with Klimt's painting allows us to appreciate the evolution of fashion in ten years' time (the drawing is from 1898) as well as the fact that the protagonist for both artists is someone from the upper rank of society. It is not irrelevant that Wagner uses the female figure in a drawing for a metro station as a symbol of modernity.

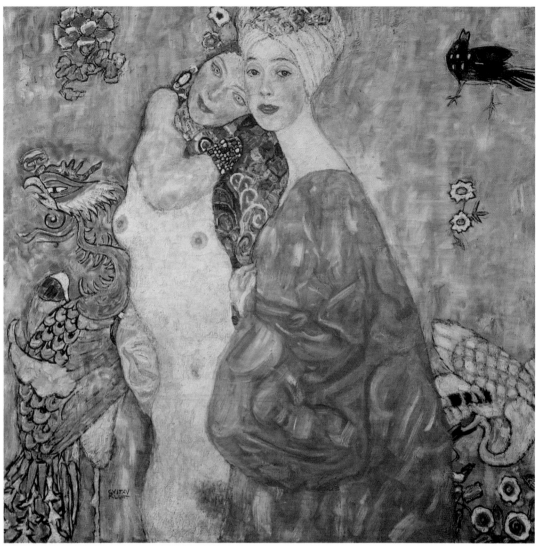

The Woman Friends
1916-1917. Oil on canvas (39 x 39 inches)

Arts, and came to collaborate closely with the government in the creation of the metropolitan railway and town planning. Klimt, on the other hand, acted away from the power centers and became one of the founders of the Viennese Secession and the master of a new generation of painters that included Schiele and Kokoschka. In spite of these opposing worlds, both artists were aware of the need the country has for modernization, and both identify with the new bourgeois society.

The life of Otto Wagner, who did not obtain full Austrian citizenship until the age of 38 due to his father's German origin, had a slow rise up the Viennese social ladder. The top rung may be seen as his being awarded the title of councilor of the Emperor's court, given in recognition of the work he carried out for the benefit of the country. Wagner represents his society as engaged by a set of political and aesthetic ideals, as may be seen in his numerous writings. These writings document a desire to impact on and mod-

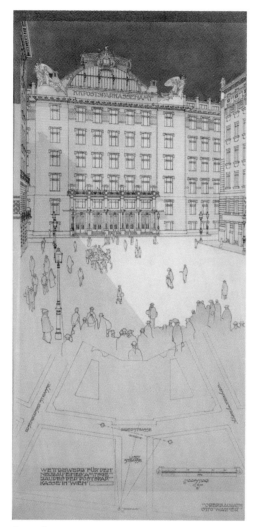

Postsparkasse
Ink on paper

ernize the society of his time, even when he was already a respected figure in the most conservative and power-linked groups. At the age of 56, he became a member of the Secession, thus fusing his ideas with the vanguard of the time along with other architects who had been his students (Hoffmann and Olbrich).

The professional life of Gustav Klimt was marked by successive scandals, although this did not reflect a repudiation by society. In 1888, Klimt was already working on the painting of the auditorium of the old Burgtheater, and hardly in need of clients. The marriage of his brother to Helene Flögue in 1891 brought Klimt into contact with the wealthiest and most liberal bourgeois sectors of the city. This was not only a source of new clients for him but also an entry into the country's most open intellectual circles. Thus, Gustav met Emilie, a woman who would profoundly affect his being. His close relationship with Emilie Flögue has caused no small number of historians to consider her his sentimental companion of many years,

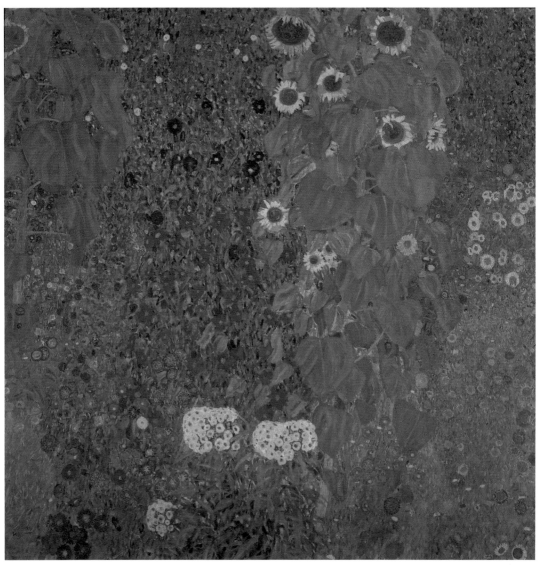

Garden with Sunflowers
1905-1906. Oil on canvas (43.31 x 43.31 inches)

although there is no conclusive proof of the full extent of their friendship. Many letters and photographs have been preserved in which the two appear to be complicit, but this is hardly uncommon for the time at which they lived. They even collaborated on the design of fabrics and clothes; the famous smocks in which Klimt painted were a design of Emilie's.

Emilie Flögue was in fact the incarnation of the modern woman we see in Klimt's pictures: she had her own haute couture business and was thus economically independent. The possible relationship they shared has become a symbol of freedom and modernity because the two of them defied the society of their time, which regarded an intimate relationship outside of matrimony as unthinkable.

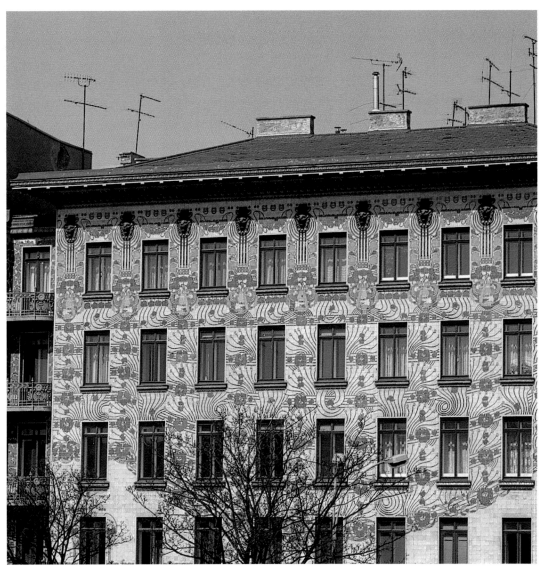

Majolica House

The Woman Friends (detail)
1916-1917. Oil on canvas (38.98 x 38.98 inches)

MODERNITY AND CLASSICISM

Ambivalence at a moment of change

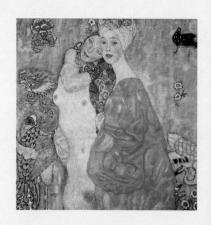

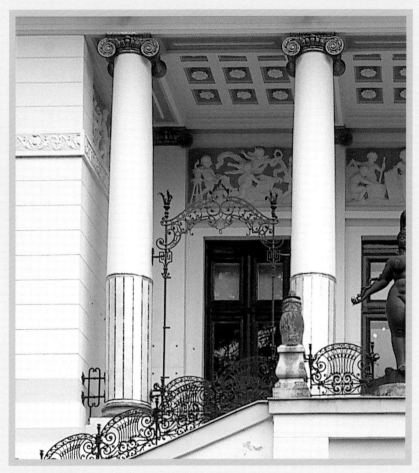

Wagner's First Villa

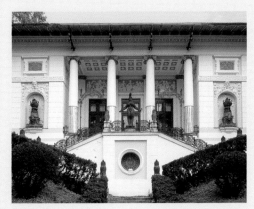

Many apparent contradictions may be found in the work of both Klimt and Wagner, and one example is the façade of the Postsparkasse, where the architect shuns academic ornamentation yet in both the proportions and other elements delivers a building that is utterly classical. Note the way Klimt introduces Orientalism as a modern decorative element yet fails to understand Asiatic reality. This constant mixture of different elements is what identifies this period as revolutionary.

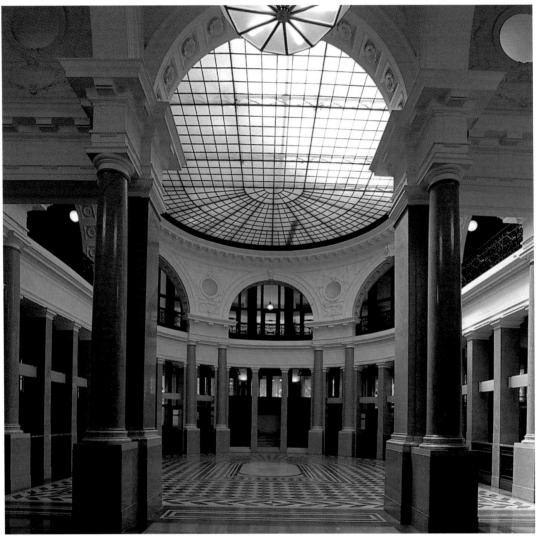

Länderbank

Wagner and Klimt worked within the city's constant tension between modernity and classicism. They had to adapt their highly academic knowledge—insufficient for a world undergoing such sweeping change—on the basis of constant trial and error. This may be seen in the slow gestation of Klimt's Faculty Paintings, for which he made hundreds of preparatory sketches, revising them constantly. It is also perceptible in the Wagner's unceasing search for the ideal dwelling that gave rise to a multitude of different solutions.

Klimt was interested in the subject matter of the Western pictorial tradition, the figure of Judith, for example, or of Danae or the allegory of Tragedy. Critical of moral conventions, Klimt used classical subjects to express his progressively modern social views. In this way he used the

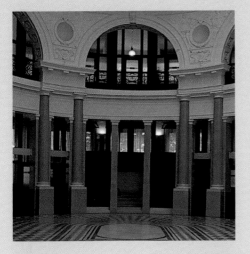

The richness of Wagner's design for the main lobby of the Länderbank shows his control of classical building discourse and his skillful versatility in its use. The interior combines two different orders: the first is that of the squared columns with straight-line entablature; the second is configured by the engaged columns of wood on a circular plan and supporting a still more powerful entablature than the first and from which the arches spring. The use of the Tuscan style and of the same materials in both cases helps unite the whole and establishes two distinct levels. These translate into two different stories inside: the entablature of the first order marks the beginning of the second floor, which has visual access through the arches to the large salon. Without much ornamentation, Wagner articulates a space which has very little to do with the classical: a plan rectangular on one side, on the other semi-circular, with two levels that access a central patio-like space. The reference to the Roman hot baths is clear in the use of the columns that support arches and the blind oculi that mark them, elements used by the Venetian architect Andrea Palladio in the Basilica in Vicenza.

The large flat iron-and-glass skylight illuminates the large central space. Thanks to this light, what would otherwise be a patio—due to its distributive function and its two superimposed galleries on a central void—becomes a *salón noble*, thus adapting a Mediterranean style to the much harsher climate of Vienna.

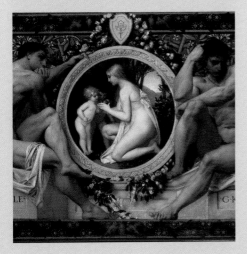

Klimt made use of the established canons of the academy in his first works, with a repertory that spans the forceful musculature of Michelangelo and the softest compositions of the early Renaissance. But while he followed the directives of the academicians by copying the forms of the great masters—using engravings and copies—Klimt was beginning to have misgivings, apparent in his own private sketches and studies. The 1884 work here, *Idyll*, respects all the academic conventions, but in the preparatory drawings there are signs of an attempt to escape such rigid teachings.

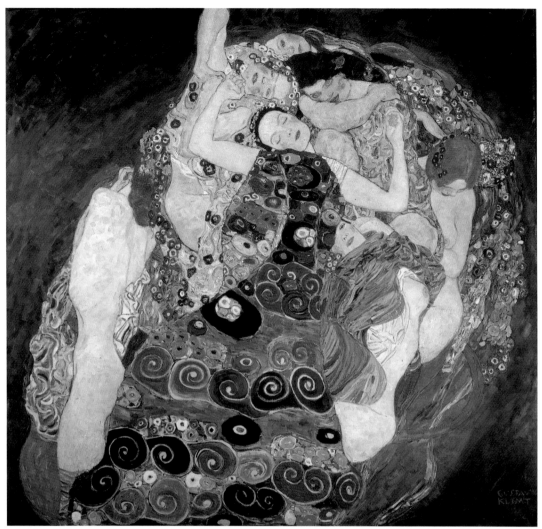

The Maiden
1913. Oil on canvas (74.8 x 78.74 inches)

myth of Danae to address female sexuality; in *Judith*, he presents a rapturous and sensual figure without the least remorse for seducing and beheading the invader Holofernes. This assimilation of mythological subjects with a modern perspective caused the first scandal in his career, in the Faculty Paintings. What was to be an allegory of the virtues of the university sciences became, through Klimt's perspective, a representation of the inex-haustible complexity of nature and the fragility of the human figure. This idea was at the center of the philosophical discourse of the time. These paintings, now destroyed, symbolize one of the earliest portrayals of the recognition of the crisis of positivism: science and reason are not enough for human progress. The University of Vienna, which had commissioned the work, could not accept such a pessimistic view. If modernity offered only

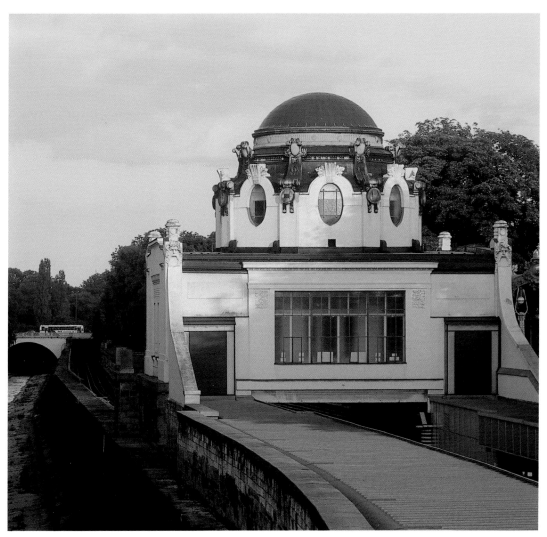

Hofpavillon

this, it was better to remain within the 18th century parameters to interpret the world.

Wagner was also touched by this duality of tradition and innovation: he used the classical formal tradition to develop a plain style purified of excessively ornamental elements. He worked arduously to adapt classical plans and schemes to the needs of modern life. In the Länderbank he took into account the need to direct the

flow of traffic of a large number of employees and clients and used to maximum advantage the natural lighting with oversized lanterns. In the Länderbank, the architect adapted a directional scheme to a difficult building site and to the needs of a bank.

In the two villas built for his family there is a clear movement to the one-family house. In the first of these houses, constructed between 1886 and 1888 (Hüte-

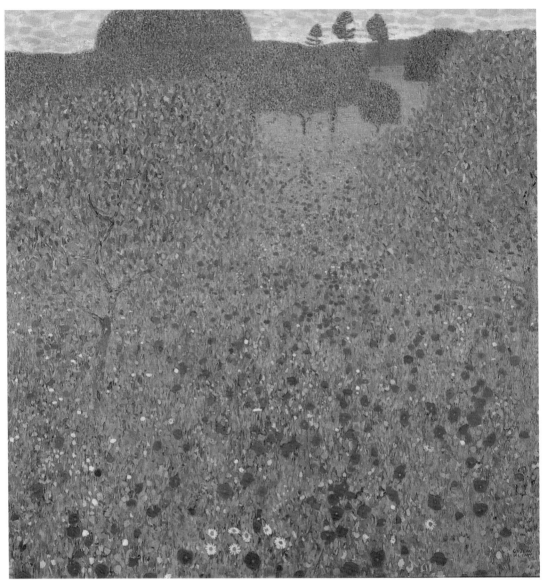

Poppy Field
1907. Oil on canvas (43.3 x 43.3 inches)

olbergstrasse 26), Wagner utilized a symmetrical plan of very Schinkelian cut—a central mass flanked by two large porticoes—to organize family life. The house built between 1912 and 1913 (Hüteolbergstrasse 28) is purposely asymmetri-

cal, based on family functions and not on pure geometrical bodies: it separates daytime activities (ground floor) from nighttime and private ones (first floor), just as most one-family houses do today.

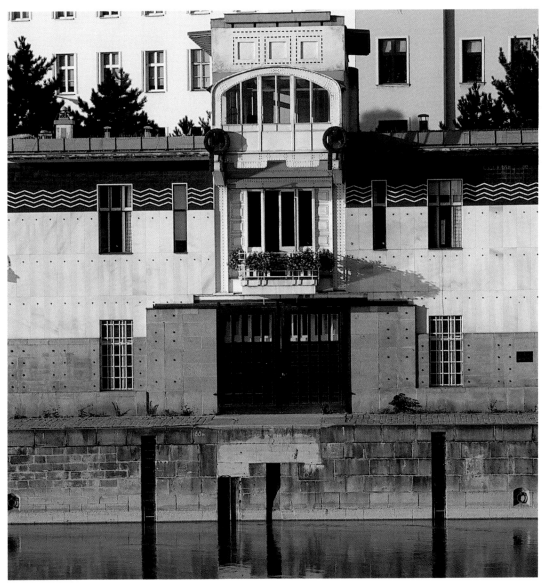

Service building for Danube River Canal navigation (part of Wagner's Vienna Metro commission)

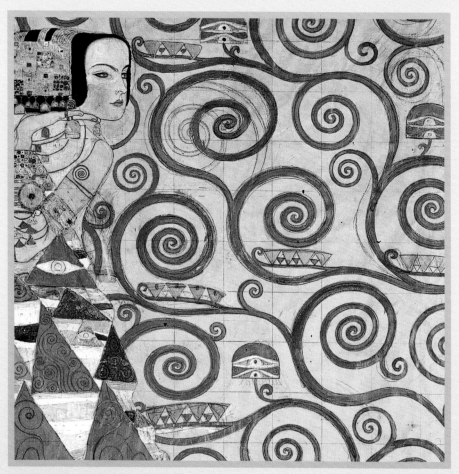

Stoclet Frieze: Expectation
1905-1909. Mixed media on parchment (75.98 x 45.28 inches)

SINUOUS LINES

New elegance

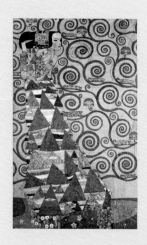

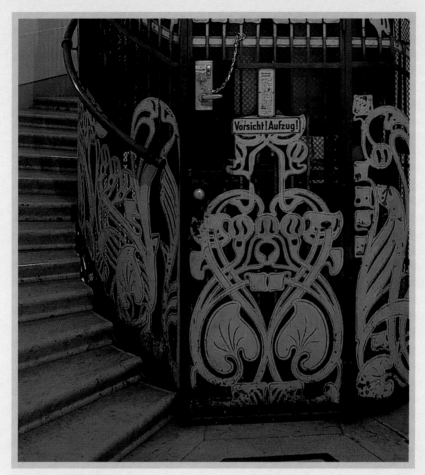

Elevator for Linke Wienzeile 38

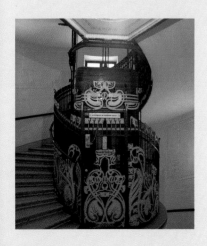

Slowly, Art Nouveau progressively replaced the neo-classical forms that were daily becoming less important to society. The new moneyed classes required an art that represented them and neo-classicism was too close to the large courts of preceding centuries. At century's end, a new aesthetic arose, based on organic forms. The undulating line came into the collective imagination of a whole generation and spoke for a whole era.

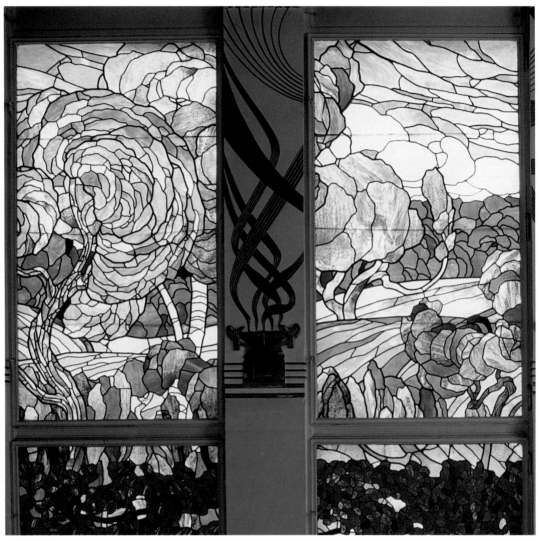

Wagner's Villa

Art Nouveau's most characteristic feature is the tendril-like or whiplash line. Wagner and Klimt inscribed their arts with this extensive general trend in fin-de-siècle Europe. What importantly distinguishes the Viennese school from others is the capability to produce elegant forms without getting lost in extremes. Wagner, in the headquarters for the Savings Bank of Austria, did not hesitate to install a round iron-and-glass skylight on a purely aesthetic basis: certainly, the skylight is a functional element, since it lets light in and channels rainwater, but other shapes would have satisfied the same needs. The conservative curved line of this oculus creates a welcoming space of exquisite elegance. This same exquisiteness is present in Klimt's pictorial treatment: flowing figures framed in large two-dimensional

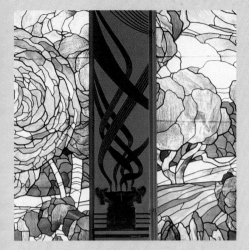

The smoke from a classical censer is the decorative motif of this room of Wagner's Villa. Not only does it rise up the walls, it actually reaches the ceiling, where it becomes a more uniform theme. The floor of the room also has a small decorative filigree, this one of a more baroque style.

Serpentine decoration is rather subtle in Wagner's work, and there is restraint in the use of large ornamental apparatus. This room, profusely decorated, with gold in the censers and the cabinets, holds to a kind of plainness with the background of white walls amid so much color.

The applied arts took on great importance over the whole course of the 19th century. The villa which Wagner built for himself in 1886 was in no small measure Schinkelian, although with time certain modifications were carried out until, in 1912, he built himself a new house and bestowed his own name on it, the Villa Wagner. In the first case, the initial project included a greenhouse in one wing, later modified to include this room. Decorated with clearly secessionist elements, like the gold detailing, the whiplash lines, and the coloring of the stained glass windows.

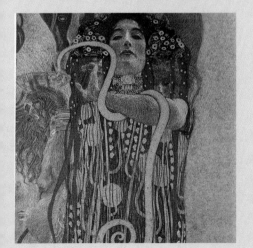

The figure of Hygieia, the benevolent daughter of Aesculapius who brought healing to humankind presided over the allegory of Medicine in Klimt's Faculty Paintings. She was depicted bearing symbols related to this discipline in her hands—the cup and the serpent, signifying power over poisons. The serpent coiled around the woman's right arm only serves to enhance the haughtiness of the figure: its sinuous form is both very characteristic of the moment and a decorative motif in its own right.

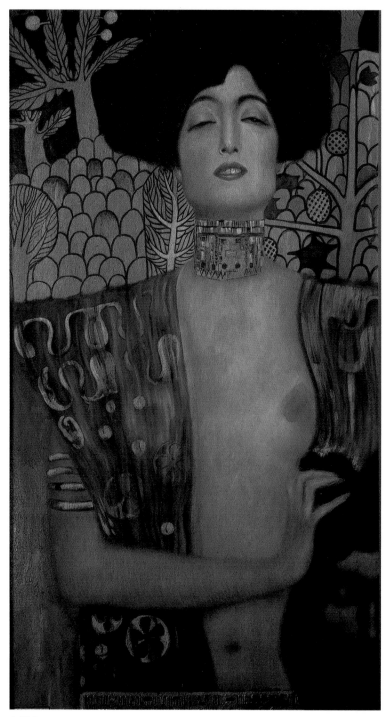

Judith I
1901. Oil on canvas (33.07 x 16.54 inches)

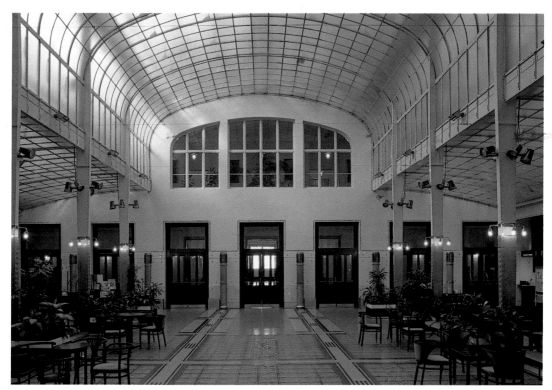

Interior, Postsparkasse of Austria

surfaces, never exaggerated, as witness the figure in the Stoclet frieze (known as *Expectation*).

The ruling architectural eclecticism of the mid-19th century sought to solve the reality of any building. Modernized classical expression replaced ornament with logic. Therefore, each element established a structural relationship with the whole piece. This gives Wagner's work a clarity and plainness that are striking in a busy environment charged with eclecticism, for example, in the Postsparkasse of Austria or the stations for the Vienna U-Bahn. In all of his buildings a new type of ornamentation appears: small floral motifs that contrast with the clarity of the body of the building. The constructive logic is cold and functional but the finishes are designed to smooth the architecture's hard edges. The Karlplatz pavilion is a parallelepiped with a central mass overhead in the form of an arch, built with iron and oversize windows. This structure is very basic, but the decorative elements mirror this simplicity. In spite of an apparent lack of any classical system, there is an undeniable classical undercurrent: the iron stanchions act as columns and the line of gold flowers as frieze lie beneath what one might call a classical entablature.

Klimt created a whole personal language based on a line that was never straight, always undulant. In this, the painter was acting with much greater freedom than any architect, with the possible exception of Antoni Gaudí(1852-1926). Klimt's paintings show a well-defined form but he is interested in setting down the primitive, the unbounded, the shadowy.

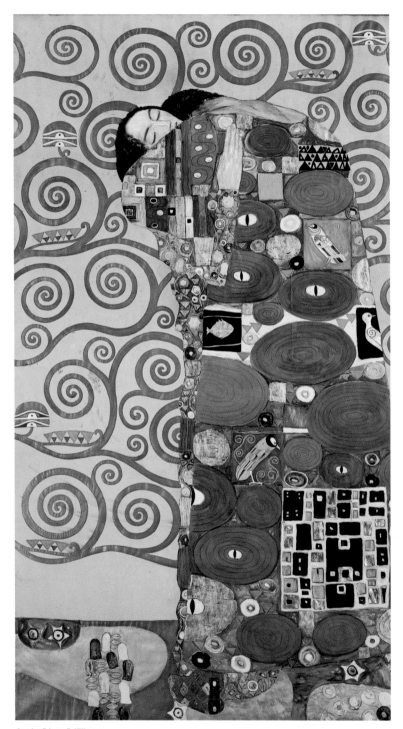

Stoclet Frieze: Fulfillment
1905-1909. Mixed media on parchment (76.38 x 47.64 inches)

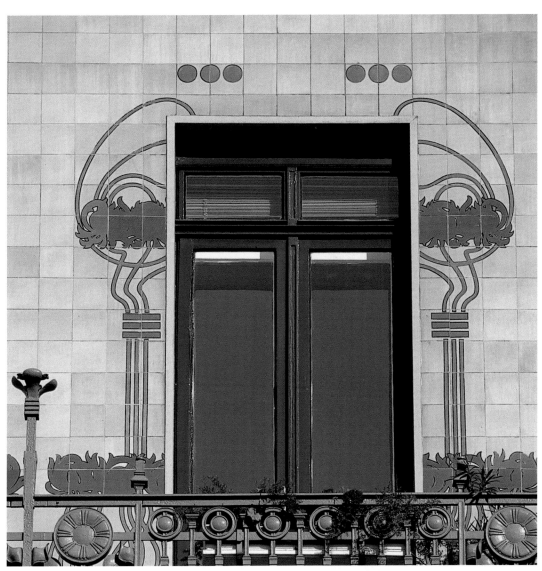

Majolica House

While Wagner's world is rational and functional, Klimt moves toward what is irrational and symbolic. Klimt is not portraying Judith's heroic acts: he centers on her lack of scruples, her amorality. The aquatic snakes from Central European legends help Klimt inquire into a more authentic, pre-rational reality where everything flows and anything is possible.

These ideas are typical of the whole transition of the century, but the finesse Klimt knew how to bestow on his figures is a personal mark. All of his figures are possessed of a superb elegance, a distinctive feature which the haute bourgeoisie, needing its own signs of identity, did not hesitate to make its own by converting the painter into the official portraitist of their economic elite.

GUSTAV KLIMT

GUSTAV KLIMT 1862-1918

Admiration for Gustav Klimt has continued to grow throughout the 20th century. The elegance of his figures, the technical precision of his canvases, and the mystique surrounding Modernist fin-de-siècle Vienna are some of the elements that help us understand his fame.

Perhaps one of the most attractive elements in his work is his capacity to capture the essence of basic human themes with figures that stand as powerful symbols. Gustav Klimt's work is easily recognizable by the contemporary viewer because his figurative language needs no great historical or mythological explanation. The simplicity of his compositions enables their use as archetypal and symbolic figures. *The Kiss* attracts not only because of its exquisite forms but because it condenses into two figures an entire series of modern concepts—love, the couple, passion, the fusion of two people—created in the 19th century yet living still today. The aesthetic and the modern taste of the Jugendstil, Art Nouveau, or Modernism—whatever we choose to call it—with all its idealism and powerful romantic charge, are still alive for us today: its language and forms continue to fascinate.

Gustav Klimt grew up in turn-of-the-century Imperialist Vienna. He was the second of seven children in a family of Bohemian artisans and set up in the capital of the Empire when Gustav was eight years old. Not until he was fourteen would he go to art school (Vienna's School of Industrial Arts). It was here that the education system sought to create qualified technicians to improve the country's manufactured products, as these were largely artisanal and were considered inferior to English products. The school collaborated with the Austrian Imperial Museum to provide optimal training for the students, but for all the level of specialization and costs involved, its influence on the business world was limited. Klimt never ceased to be uncritical of the poor education provided in this school, but upon finishing his studies in 1883, he put together a company of artists along with his brother Ernst (a sculptor) and the painter Franz Matsch(1861-1942). They had the implicit support of their teacher, museum director Rudolf Eitelberg, who remained faithful to their cause. The three young artists took advantage of the large number of buildings that were coming to completion on the Ringstrasse to set up a small studio under the name of the Company of Artists (Känstlercompanie). The endeavor offered the possibility of accepting different types of decoration jobs at economical prices, a way of starting their professional careers. It grew progressively. Partly, its growth was due to the good recommendation given by Eitelberg and the quality of the work. Thus, between 1886 and 1888, the Company of Artists worked on the ceilings of the stairway in the Burgtheater and on the walls of the stairway in the Imperial Museum of Art History. In 1887, the Vienna Town Hall commissioned Klimt with a painting that represented the interior of the old Burgtheater. But instead of painting the architecture or the actors, Klimt opted to paint the boxes, presenting in detail all the wealthy people who weekly

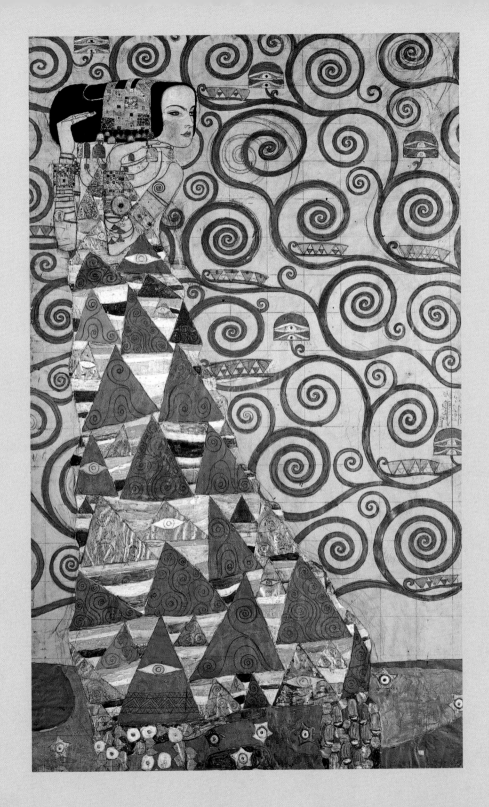

filled the theater and so presenting not the theater but the theater-goer. With this piece, the artist's fame among the people he had portrayed grew spectacularly and, with it, the number of private commissions for portraits, a better source of funds than building decorations.

In 1891, Klimt joined the Association of Plastic Artists of Vienna, where the most restless artists of the time gathered—what would become the nucleus of the Secession. That year marked Klimt's first nomination for a chair at the Academy, a post he would never receive. A year later came the deaths of his father and of his brother. Klimt continued working alongside Matsch on the com-mission to decorate the facilities (1894). This achievement would mean the beginning of the artist's maturity and his break with bour-geois ideals through his portrayal of academic knowledge as being futile in the face of the vast enormity of the universe.

In 1897, following the disintegration of the Association of Plas-tic Artists, Klimt and the architects Joseph Maria Olbricht and Joseph Hoffmann founded the Viennese Secession and then, a year later, the journal *Ver Sacrum*. The publication (Sacred Spring, in English) expounded the group's aesthetic ideas, and for five years the vitality of this group brought profit to all of its members. What had opened in 1891 as a need to link modern artists in an almost feudal country had now become a veritable aesthetic rev-olution. Ever influenced by Paris and by Art Nouveau, the Seces-sion reacted against a neo-classical art that showed no relation to contemporary problems. The desire for freedom, the awareness of being a cultural elite, and the idea that art should impact the soci-ety of its time united a group of highly distinct artists and inevitably united different languages and interests. In his last 20 years of life, Klimt kept up his intense activity, never ceasing to be a part of the Vienna intelligentsia (in 1906 he founded the League of Austrian Artists, participating and presiding over it from 1912). He gradu-ally occupied himself more with his own work, with a highly per-sonal language which, in spite of everything else, never stopped evolving.

Klimt's private life was never very public. He never married and lived with close relations a life of meticulous habit, in sharp con-trast to the myth of womanizer and Bohemian that followed him throughout his life. His relationship with Emilie Flöge was very intense, but it is difficult to establish what type of relationship they had since neither ever spoke of the other in public. It has been pos-sible to show that he had three illegitimate children, one with Maria Ucicky and two with Marie Zimmermann, which brought him the reputation of a libertine. But not many details of his per-sonal life are known, and on more than one occasion he himself commented that he was not interesting.

Klimt died in 1918 of a cerebral hemorrhage after dedicating almost his entire career to painting the figure of woman.

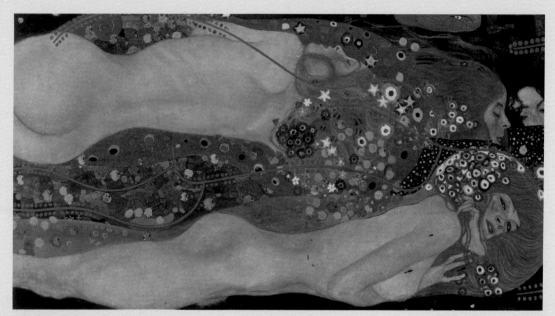

Water Serpents II
1904. Oil on canvas (31.54 x 77 inches)

THE THREE AGES OF WOMAN

1905. Oil on canvas (70.87 x 70.87 inches)

One of the obsessions we find present at the turn of the century, especially prominent in this Viennese painter, is an interest in the feminine: the female figure accounts for the greater part of Klimt's work. In Judeo-Christian culture, where woman was held to be no more than a vessel for male procreation, the feminine had always represented sin or the superfluous. But the crisis in values that broke out at century's end brought such clichés of sexual identity tumbling down.

Klimt was the first European visual artist to portray a nude woman pregnant (in his 1903 painting *Hope I*), and thus captured all the energy of a body capable of engendering life. It is this same primordial force that underlies *The Three Ages of Woman*(1905): if every-thing human is condemned to perish without a trace, woman at least has the capacity to give birth and repro-duce the human form. This is in contrast to the moral beliefs of the time, for in this painting a mother without a husband is not negative but a statement of the repro-ductive power of woman.

In his erotic drawings Klimt broke the taboos of his time by acknowledging and celebrating female sexuality in his portrayal of female autoeroticism. Klimt presented a world where woman was autonomous, without need of any man either sexually or otherwise. In *The Kiss*(1907-1908) or in *Fulfillment* (from the Stoclet Frieze) a masculine figure appears, embracing a woman. Yet once again, the feminine figure is the pro-tagonist: the face of the man is hardly seen in the first canvas, and it totally disappears in the second. More-over, his body is an amorphous mass that accompanies the woman. In many sketches and drawings, Klimt por-trayed two women embracing, removing the masculine figure entirely.

Stoclet Frieze: Fulfillment
1905-1909. Mixed media on parchment (76.38 x 47.64 inches)

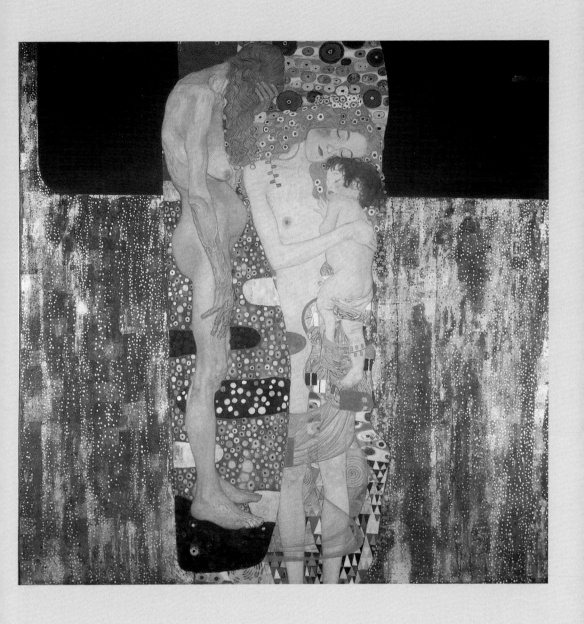

THE HYMN OF JOY, FROM THE BEETHOVEN FRIEZE

1902. Casein paint on stucco (86.61 x 185.04 inches)

In 1902, the Secession held its 14th exhibition, one of the most important events of the Viennese group. It was celebrated in the building specifically designed for it *ex profeso* by Josef Hoffmann. Many artists collaborated on the decoration of the frieze to show the interrelation among different disciplines, one of the goals of the secessionist group. The exhibition's other great aim, apart from unity of the arts, was to demonstrate that art is a living force capable of transforming society, an idea inherited directly from German Romanticism. The group felt Beethoven best embodied these artistic ideals.

Klimt did four decorative panels for one of the four decorative sections in one of the rooms of the Hoffmann Pavilion. The panels represented Beethoven's Ninth Symphony, in which the composer set Schiller's "Ode to Joy" to music. While Klimt's interpretation varied somewhat from the text, it still made use of allegory to present the central theme of the Romantic poem, the liberation of humanity through visual art and poetry. In Klimt's work, humankind is transformed into a heroic figure, personified in a single person. In the panel "Poetry," this hero grows literally out of an embrace with Poetry as the culmination of the quest for the happiness of humanity.

Because the frieze was originally planned as an ephemeral piece—the pavilion was to be demolished after the exhibition, but this did not happen—Klimt worked in a very free fashion, without following canonical proportions for the figures. For many critics, this is the beginning of his refined stylization. The free approach included a very novel technique, done with encrusted stones and fragments of mirror, imitation jewelry elements, and an endless array of materials that enlivened the artist's creation.

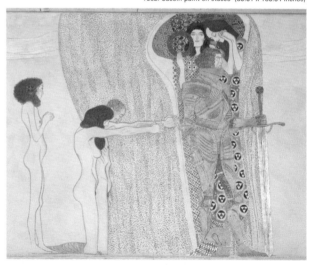

The Yearning for Happiness.
From The Beethoven Frieze.
1902. Casein paint on stucco (86.61 x 185.04 inches)

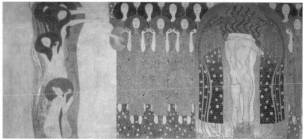

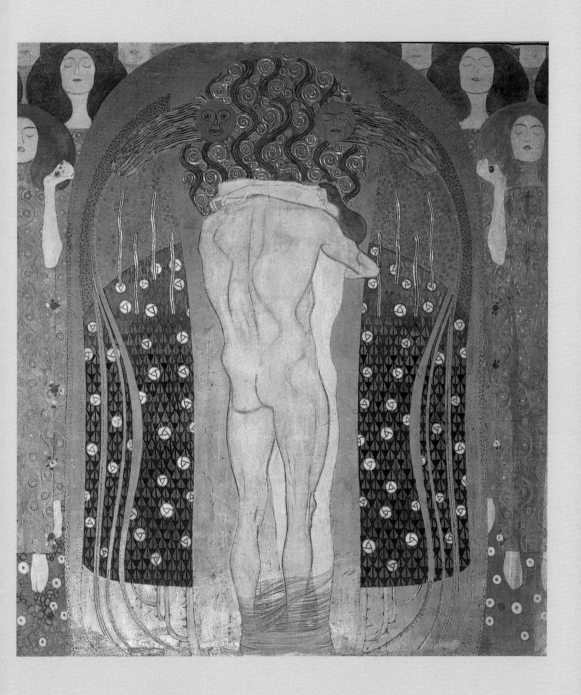

PORTRAIT OF SONJA KNIPS

1898. Oil on canvas (57 x 57 inches)

Far from being a hell-raising Bohemian artist, as some commentators have wished to present him, Gustav Klimt was always respected and admired in the different circles of his city, among artists, among the bourgeoisie, and among the aristocracy. Klimt had bourgeoisie clients thanks to his contacts and the great quality of his portraits: he became one of the most fashionable painters in the commercial class. His confrontational posture toward state artistic policy in 1905, or the many criticisms launched against his work in conservative camps raised his prestige even higher in an empire that still lived under the *ancien régime*.

Portraiture technique must by definition be faithful to reality: it is in that sense a genre little prone to the stylization of figures. But it is precisely this that is one of the most visible characteristics in the mature work of Klimt. The pictures done up to the end of the decade of the 1890s, like the portrait here of Sonja Knips, posit the figure in an expressionist-realist setting. Both the attire and the body of the woman are realist, as are the flowers that appear in the upper angles and which act as counterweight to the figure. In the portrait of Margaret Stonborough-Wittgenstein, regardless of the reference which the decorative elements make to a concrete setting—the green strip of floor, the black line on the floorboard, and the bluish strip on the wall, with different ornaments—they nevertheless mark an inclination toward the abstraction of reality, creating a stylishly evocative but accurate portrayal of the subject.

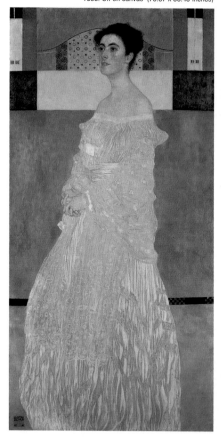

Portrait of Margaret Stonborough-Wittgenstein
1905. Oil on canvas (70.87 x 35.43 inches)

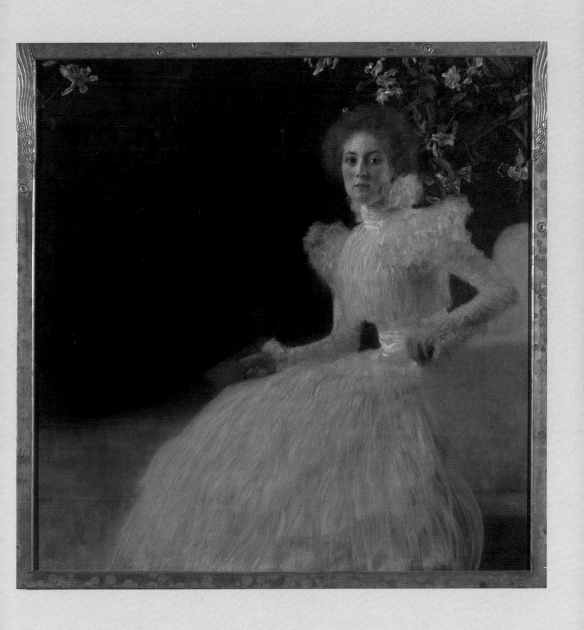

PORTRAIT OF FRIEDERIKE MARIA BEER

1916. Oil on canvas (23.5 x 33.1 inches)

From the beginning of his artistic career, Klimt collected Japanese prints. He was probably influenced by the interest these art objects awoke in Paris from the 1880s onward. Indeed, many other fin-de-siècle painters showed a fascination with Japanese works because they represented an exotic alternative to the Renaissance perspective at a time when the West was seeking new ways of presenting reality.

In Klimt's last portraits, his interest in Japanese prints makes itself evident in the decoration of the space surrounding the subject. The backdrop in these portraits is replete with human figures done in the Japanese manner, as if the piece were a tapestry on which the main protagonist is worked in something almost like relief. In introducing Orientalism, what Klimt was primarily seeking was an exotic motif with which to decorate his portraits, and this satisfied the elitism of his clients. In these works he shunned the Renaissance perspective: his figures come out volumeless, nearly planes. Nor are the portrayed figures touching the ground, a feature which causes a certain spatial conflation between the bodies in the background and the central body. This underscores the exotic and refined portrayal of the subject.

The women's clothing here is another decorative element. In the case of Friederike Maria Beer, the dress exudes the same Oriental connotations, while the irreal sophistication of Elisabeth Bacchofen-Echt's dress afforded the painter the opportunity to play up the features of a light mantle which cascades over the baroness.

The mastery and confidence of these portraits show that Klimt knew how to keep control of the piece and add his own personal style to it. The delicacy we see here is visible both in the small details and in the vivacious faces of both women.

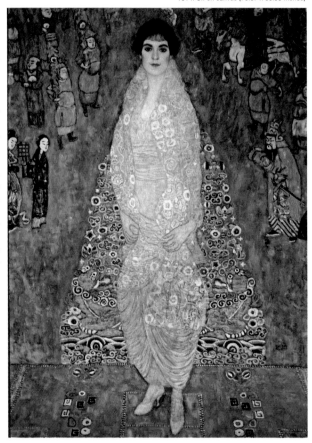

Portrait of Baroness Elisabeth Bacchofen-Echt
1914. Oil on canvas (70.87 x 50.39 inches)

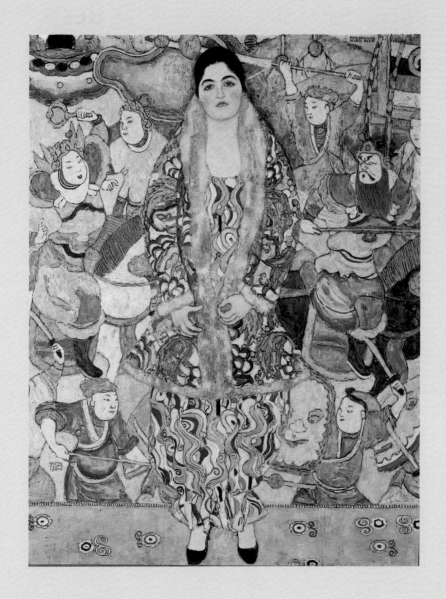

BEECH FOREST

1902. Oil on canvas (39.37 x 39.37 inches)

Klimt's landscapes, almost always in a square format, shun any sort of narrative (such as the inclusion of human figures or emblematic locations) in order to center on an elegant, balanced composition. The way the light falls on objects is one of the main themes of these paintings, influenced in no small measure by the impressionist school of Paris, which Klimt greatly admired.

The pictures done in the first decade of the 20th century stand out not only because of their absence of clear perspectives but also due to the predominance of the patch of color over the chiaroscuro. In *Birch Forest*, brown tones dominate the whole piece and the succession of trunks we see creates the sensation of depth, heightened by the background of blue sky, where the tops of the trees are lopped off in the upper third of the picture. In spite of the careful composition, however, the painting does not frame a single tree in its entirety, nor does it attempt to define any other element. This fragmentation Klimt surely learned from Japanese prints, where the notion of composition differs from the Western form, and also from photography, whose framings revolutionized the world of painting from the end of the 19th century.

The very light green in the topmost leaves and the points of bright auburn on different sections of bark indicate the effect of the first rays of sunlight, just beginning to illuminate the wood, which link the Romantic vision of nature with the study of light taking place in fin-de-siècle Paris—and of course with modernity.

Birch Forest
1903. Oil on canvas (43.3 x 43.3 inches)

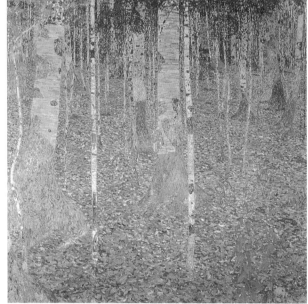

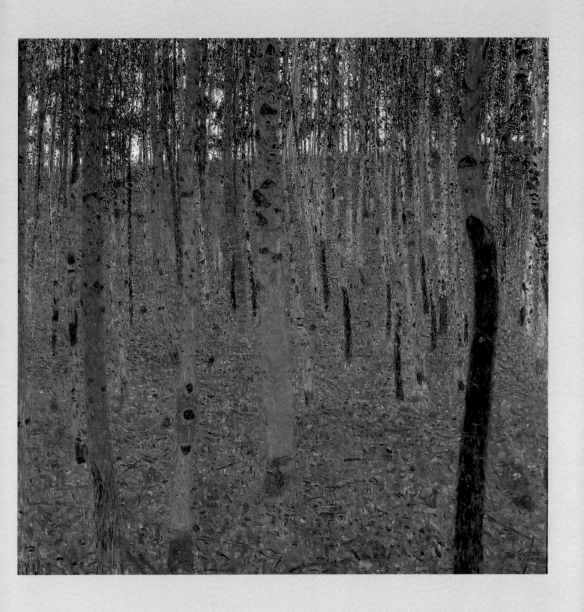

AVENUE IN SCHLOB KAMMER PARK

1912. Oil on canvas (43.3 x 43.3 inches)

Some of Klimt's landscapes include architectural elements. But in spite of this trace of human activity they are, like the other landscapes, works of a very marked atemporality, without any human actually engaged in action and where the architecture itself is treated like one more element in the landscape.

In *Avenue in Schloss Kammer Park*, Klimt painted a path that leads to a building, a road with an acutely unnatural perspective. In this piece the focus is on the foliage of the trees and the colors of the trunks. The image is not as important as its execution: the swift brushstrokes followed by small brushed on spots dominate the picture and annul in some measure the depth-of-field brought about by the lines of trees.

Klimt painted the greater part of his landscapes during long summer stays with the Flöge family at Lake Atter. On these vacations, Klimt brought with him and studied collections of Japanese prints. These landscape pictures seem to have represented a rest from the portraiture and the symbolism he did in the capital, although he completed some of the rural work in his Vienna studio from notes made in the field.

While these works are not in any way related to those based on the human figure, the painter's interest remains the same, and both types of painting denote the same elegance and the same path toward modernity.

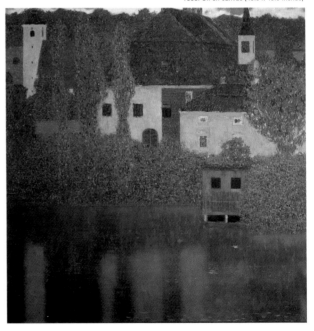

Schlob Kammer on the Attersee I
1908. Oil on canvas (43.3 x 43.3 inches)

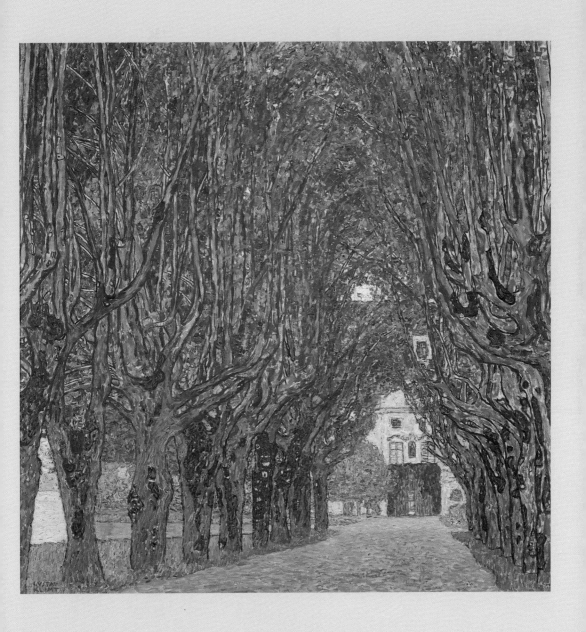

DANAE

1907-1908. Oil on canvas (30.32 x 32.68 inches)

Klimt is one of the few Modernists who used themes from classical mythology in his work without adhering to the academic canon. He did this from the outset of his artistic career, always centering on feminine figures. His representation of *Pallas Athena*, in 1898, shows the Greek goddess in a highly personal form. Normally, she is represented full figure, but Klimt decided on a partial image, something like a portrait format. Because the figure of the goddess is so close, it loses the appearance of divinity and seems more real, more human. At the same time the almost physical presence of the armor and the grotesque mask on the breastplate, along with the helmet and the lance, give the woman a force and a power unusual for the period.

Klimt used mythology to portray female sexuality, a much more strange and scandalous subject for his time than was the portrayal of a strong woman. The myth of Danae tells of how this princess, enclosed in her rooms by her father to keep her from knowing any man, was seduced by Zeus. The god entered her chamber in the form of a shower of gold and the hero Perseus was born of this. Klimt chose this theme because of the existence of a tradition: Rembrandt, Titian, and other great painters had used this myth precisely because it allowed them to paint the nude female figure. But Klimt did not represent the moment prior to the entrance of the Olympian god, as had his predecessors, but the moment of the union of Zeus and Danae. Klimt's interest in woman's sexuality was presented under the classical title, but Danae has lost the attributes the myth gives her and the painting's focus is on the woman's pleasure rather than an anatomical form.

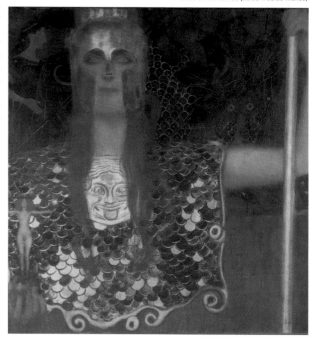

Pallas Athena
1898. Oil on canvas (29.53 x 29.53 inches)

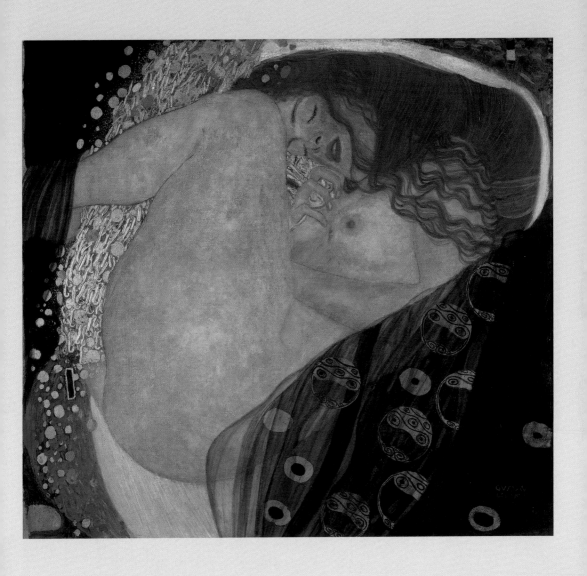

JUDITH I

1901. Oil on canvas (33.07 x 16.54 inches)

The figure of the femme fatale established itself as a concept at century's end via literary and pictorial works. Klimt was one of the creators of this new feminine archetype. *Judith I* is one of the pictures where the woman takes the form of a femme fatale, a woman capable of seducing a man to bring about his downfall. The Biblical myth tells the story of the Jewish heroine, who seduced and decapitated the enemy general, Holofernes. Far from presenting Judith at the moment of executing Holofernes (the classical view of the subject), Klimt opts to show Judith outside of time without engaging in any action: in a partially clothed state, Judith holds the head of the decapitated general. Here there is no moral lesson being painted, only the portrait of Judith, a woman free of guilt and victorious over a man.

Klimt's first controversial work involved what are known as the Faculty Paintings. These three paintings were to show the good of the sciences for society, but Klimt not only departed from a classical depiction, with a number of "scandalous" nudes, he also used the paintings to show human knowledge as helpless against the powers of the universe and nature. The Education Ministry, which had commissioned the pictures in 1894, could not or would not accept this. The main figures in these three allegories (Medicine, Jurisprudence, and Philosophy) were also women who, like Judith, Athena, or Danae were not passive objects of beauty but instead were powerful, as we may observe in the figure of Hygieia, allegorized as Medicine.

These important pieces were burned in 1945 by the SS and are now sadly visible only in sketches and black-and-white photographs.

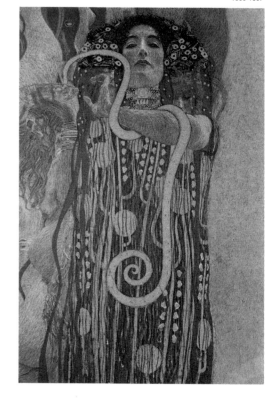

Medicine (Hygieia)
1900-1907

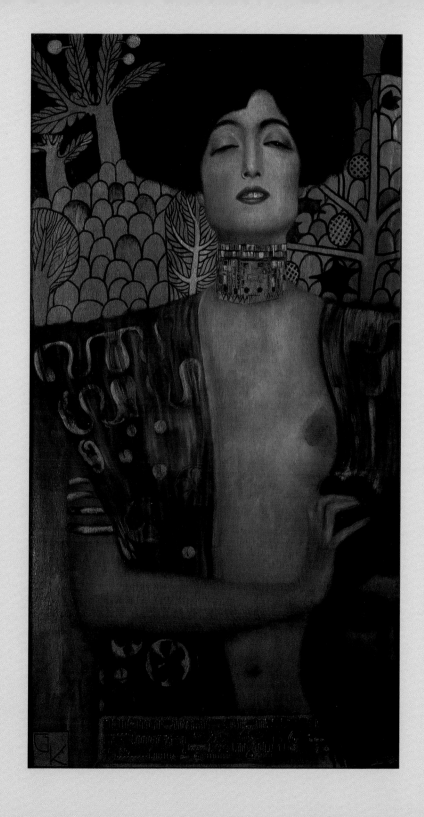

THE MAIDEN

1913. Oil on canvas (74.8 x 78.74 inches)

For *Medicine* (Hygieia) in the Faculty Series, Klimt was already imagining humanity as a mass of intermingled bodies in a single chaotic unit. The artist was playing with the plasticity of bodies, finding ways to portray an endless array of capricious foreshortening of the human form, relaxed or tense, without having to justify the portrayals. He had previously begun discarding spatial referents in his series called "paintings of humankind" (examples include *The Maiden* or the unfinished *The Virgin*). Klimt focuses on the figure that appears to arise from the amorphous mass of other figures and decorative elements to achieve a clear, direct effect on the title's theme. The lack of a real setting renders the subject archetypal.

In *The Maiden*, then, the partially nude bodies of the women are intermingled with decorative elements that are no more than planes. But they are clearly differentiated by an alternation of colors: the human forms are painted in a range of roses and stand out from among the vivid colors of the ornamentation. The meticulous and exquisite delicacy with which the women are rendered also contrasts with the brusque and thick line of the fabrics around them.

The superb way in which the painter has rendered the gestures of the human forms, the color contrast, the movement of the human mass and the whole arrangement are testament to the maturation of Klimt's visual genius.

The Virgin
1917-1918 (unfinished) (65.35 x 74.8 inches)

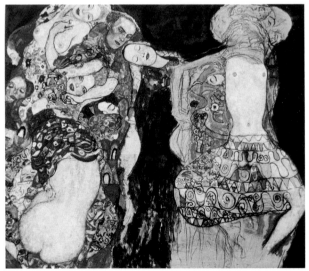

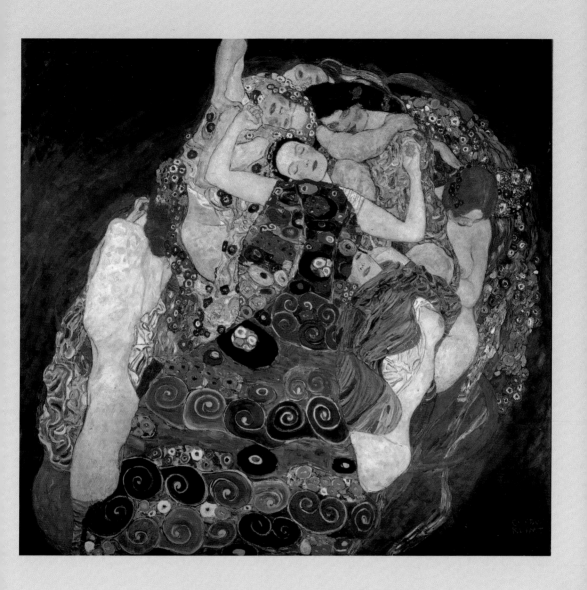

LIST OF IMAGES

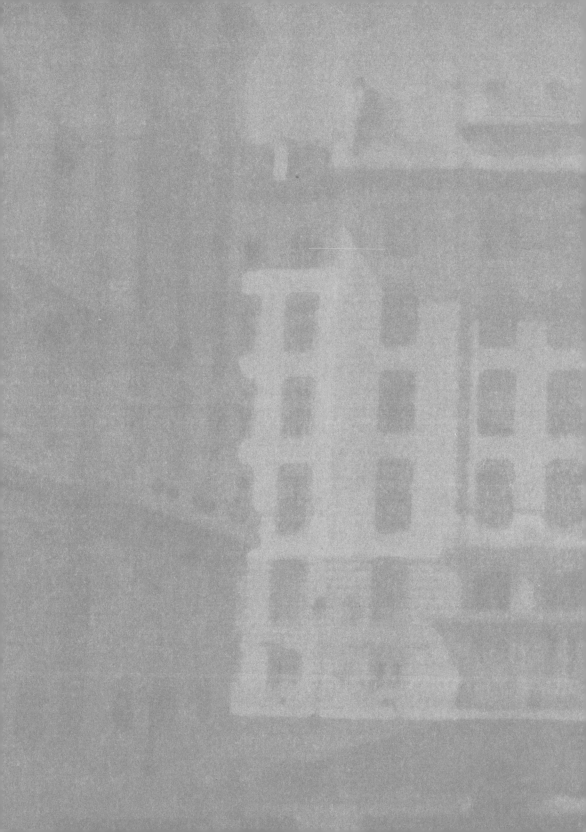